PHOTOGRAPHY:
COMPOSITION · COLOR · DISPLAY

PHOTOGRAPHY:
COMPOSITION · COLOR · DISPLAY

Marc Levey, Margaret Irish & Samuel Kazdan

Amphoto
American Photographic Book Publishing Co., Inc.
New York, New York

Library of Congress Cataloging in Publication Data

Levey, Marc B
 Photography, composition, color, display.

 Includes index.
 1. Composition (Photography) 2. Color
photography. 3. Photographs—Trimming, mounting,
etc. I. Irish, Margaret, joint author.
II. Kazdan, Samuel, joint author. III. Title.
TR179.L48 770′.28 79-584

ISBN: 0-8174-2460-1 (hardbound)
ISBN: 0-8174-2134-3 (softbound)

Manufactured in the United States of America

Dedication

To Patricia Levey, whose unfailing uninterest in the jargon and minutiae of photography so helped us to maintain our perspective.

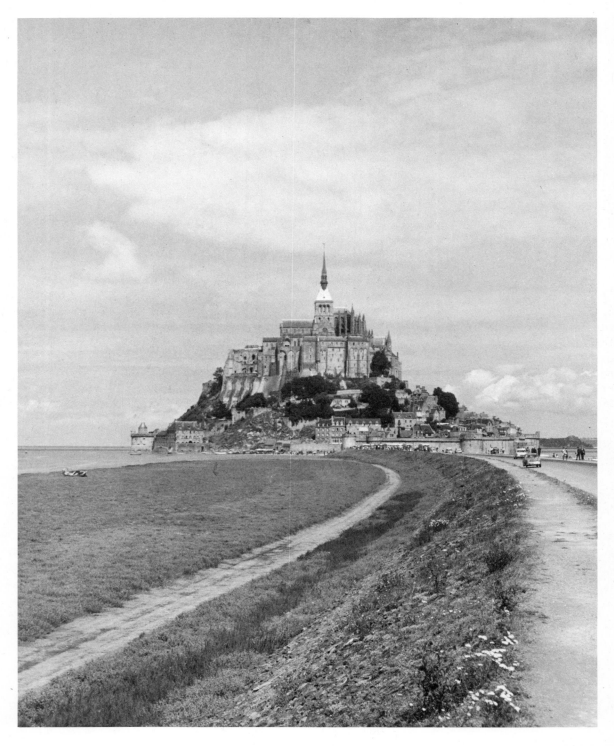

Photo by L. P. Greenhill, F.R.P.S.

Acknowledgments

Any book has more people—and in this case, companies—behind it than the title page suggests. We are grateful not only to Royal Dossett for his contribution to the section on prints and their display, but also to the Edmund Scientific Company for the material necessary to make a fisheye lens and to McDonald Photo Products, Inc., for the framing material it contributed.

We are also indebted to the student and professional photographers who permitted us to use their work in illustration and whose questions inspired both the content and the orientation of the book.

Finally, we'd like to thank Tom Burkholder (who lent us his typewriter when he didn't have to) and Mark, who would have, if he'd had one.

Thank you.

Photo by Bill Coleman.

Contents

Photo by Bill Coleman.

Preface

In the world of rules
There are no rules
Only fools
 —Ogden Nash,
 Carnival of the Animals

Photography has its esthetics and the necessary evil of rules that accompany them. We prefer to consider what we have to offer as *principles*—subjective they may be, but unalterable they are not. Esthetic questions are no more ours to answer than our suggestions are yours to accept as indisputable truths. The photograph may be one of the most elusive art forms, captured as it is in the brief span of a shutter's click. And the essence of that art form, from content through treatment of subject matter, is determined only by you, the photographer.

We have tested our subjectivity and offer what has panned out as a starting point. Our intention remains to help you gain certain abilities as a photographer, not to dictate what you will finally become as a craftsman. As such, our suggestions are aimed at setting out first principles, so that you may understand photography better and achieve greater success in what you attempt. The ultimate success is your satisfaction in the print, just as the proof is in the pudding when you're learning to cook.

And don't be surprised if you are *never* completely happy with your results—the best photographers rarely are.

Introduction

Assembled on your title page we may look a motley crew: How *do* three people write a book? Well, a book's more than just the being committed to paper, and this book is no exception. The three of us created this book from our various perspectives and abilities as professional photographer and teacher, writer with a strong interest in esthetics, and amateur photographer with a good literary background.

The end product of our efforts is a book that stresses applications: not "what it is technically called," but "how you can use it best."

We begin with first considerations: What are you going to photograph? From there we diverge into a discussion on composition, primarily from a black-and-white standpoint. Included are previsioning questions about scenes and your equipment's ability to render what you see and about mood creation, and a breakdown of spatial relationships to think about. Once you can say you know why you're taking a photograph and know what you want it to look like, you're well on your way to getting results.

Color is such an important compositional tool that we've treated it separately (Chapter II). If you're working in color it's impossible to separate it from its effect on content and, thus, its over-all significance to your composition. We offer you some technical certainties about color's properties and a general guide to using it. Color quality, its physical location in a scene, the relation of one color to other colors, and the limited ability of film to render it as you see it are all factors to weigh when composing a photograph in color. This creative quartet of color as a key to content and composition necessitates discussion of exposure variation, color dominance vs. balance, depth of field, psychological impact, and the effects of natural light, as well as the technical aspects of color film and the way in which it translates what you see.

The third chapter offers a variety of techniques adaptable to photography as an abstract art form. Diffusion effects and equipment, photomicrography, "prisms," and close-up techniques are some of the topics covered. Make your own prism device or a fisheye lens for less than $10, experiment with multiple exposures, reflection, panning, texture screens, or use color TV for special effects. The list of variations and ways to deviate from first principles is as long as you care to make it.

Finally, a book on photography would not be complete without the mention of printing options (Chapter III) and the mounting, framing, and displaying techniques covered in Chapter IV. We are indebted to Royal Dossett for this material, which has been extracted from his *Book X-6*.

Black-and-white composition is the best place to start when learning photography. Photo by Marc Levey.

I Composition

Content, How Important?

As a photographer, you are constantly making selective decisions about the subjects you wish to capture. First you must decide what to shoot, then you must decide how best to transfer the image in your mind onto film.

In most instances, you choose the content of your photograph before you think about composition or any technical considerations. Your choice of subject is the most personal decision you make during the creative process.

While content comes first for most of us, this does not always have to be so. A striking compositional or lighting pattern might transcend any physical content and become the photographer's initial and overriding concern.

So don't overlook possibilities: There's no limit except that of your own imagination. There's no more a law saying what you must photograph than there is on how you should feel about what you shoot. Further, there's no truth in the rumor that photography must be serious-minded. Humor in photography has its own unique place and possibilities. Quite literally, the sky is not even the limit.

Composition in photography requires the manipulation of subject matter, color, lighting, and other technical mechanics. It is a complex process and, for the most part, a subjective one. The end result of combining these various components is the creation of a personal statement. We all perceive things a little differently, and how we choose to interpret our subject says something about us to others. To ensure success (that is, to gain the ability to record on film what you see *and* how you see it) the photographic artist needs to "think out" his photograph before he shoots.

Failure to think out a shot produces a picture with a simple recording function. We've all seen the "snapshot" of the birthday when Johnny fell into his cake, or the one of Dad's 23-inch pike. Such photos are taken to record a moment, usually in haste. Pictures that employ compositional techniques require more forethought than "grab" shots, so that composition becomes a more selective act.

In this first chapter we will treat composition as a process, breaking it down into separate categories dealing with previsioning, brightness, three-dimensionality, selective focusing, lens selection, mass, mood, spatial relationships, and forms. In Chapter II we will discuss color as a compositional tool. Putting these concepts into a series of workable techniques is something you will have to experiment with on your own. For the time being, let's be concerned with how you can capture on film the images you see in your mind.

The narrow range of highlights and shadows in this scene, resulting from an overcast sky, creates a moody feeling. The picture relies heavily on a strong composition for its visual impact. Photo by James Forkner.

THE BASIC STEPS

What to Think of First

There are two basic steps needed to "see photographically."

1. You must realize that your camera lens and film will not faithfully record what your eyes see.
2. You'll need to learn how to modify what your eyes see in terms of that equipment.

It does take practice, but making decisions about color control, perspective, and content should occur before you shoot. What you are striving for is assured results. This is accomplished by considering, before you click that shutter, everything that cropping later will not cure. If recording an event or subject is not sufficient, then you must "think through" your photographs first. Remember that the transposition onto film of what you see and how you feel about it alters the rendering of it for all viewers. This is the creative process that separates "point-and-shoot" photographers from the people who take their craft more seriously.

The following factors *will* limit your ability for precise expression of what you see and

Above. A limited brightness range can produce a rather dull photograph. Photo by Marc Levey.

Right. To overcome this problem, inject a point of interest into the scene; in this case, the projecting dark foreground objects. Photo by L. P. Greenhill, F.R.P.S.

the way you translate it onto film. On the other hand, these "limitations" can be considered potential creative tools, as they can be manipulated to suit your esthetic requirements. In any case, these variables affect whatever end product you see in your mind's eye, and you will have to deal with them sooner or later.

Brightness

Photographs have a much more limited range of tone or hue than the human eye can perceive. All scenes have areas of *highlights* (light areas) and *shadows* (dark areas), to some extent or another. Sometimes the brightness range is very narrow as on an overcast day.

That same scene can be very bright, with a broad brightness range, on a clear, sunny day.

Both light meters and film are limited with regard to how great a brightness range (contrast range) they can record. When they exceed their limits, either the highlights will wash out or the shadows will be black masses with no discernible detail. Many times you will have to choose which end of the range you want to use most; brightness can therefore become a selective tool for you. If the highlighted areas are of primary concern, you may have to sacrifice the shadow area details, or vice versa. It should be kept in mind that you almost always have a choice of emphasis in manipulating the

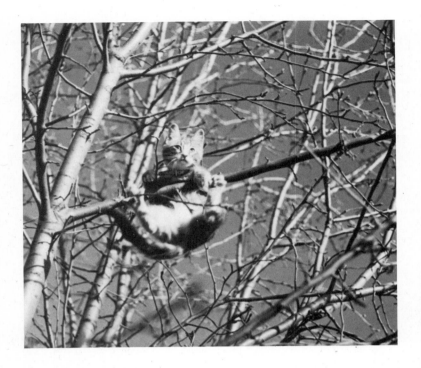

A broad brightness range reveals many shades of gray to the viewer. The way they interact in this scene commands as much attention as the cat's predicament. Photo by Marc Levey.

brightness range and that choice ought to be exercised to your greatest advantage, rather than wasted.

Here are some general guidelines to remember when considering how to use highlights and shadows in a scene you wish to capture on film:

1. If your subject has no extremes from shadows to highlights—say, less than a 3:1 ratio between the lightest and darkest areas in the scene—most exposure meters will register it accurately.
2. If there are extremes of brightness, you will need to decide which extreme, either the bright or the dark area, is more important. You can then carefully meter the selected area when shooting.
3. An excessively limited brightness range (less than two *f*-stops) may produce a flat and very dull photograph. Such a scene is not

likely to be effective, nor will it hold the viewer's attention.
4. A scene with a low brightness range can be injected with a point of interest in several ways; employing an unusual camera angle or adding a carefully placed warm color are just two methods. Even if you're just taking family photographs on an overcast day, you might find it helpful if someone were to wear a yellow shirt, for example.
5. One main point will inevitably stand out if it is appreciably lighter or darker than its surroundings. The *lighter* such an important element is, the more it will seem to project *forward* from the background. The *darker* it is, the more the feature will seem to *recede*. Either situation implies a third dimension by giving a feeling of depth to an otherwise flat, two-dimensional photo.

Here the choice of brightness range is made in favor of the detailed highlight areas. Photo by James Lukens.

The Illusion of Three-Dimensional Subjects

The third dimension—*depth*—doesn't actually exist in a photograph, since it has only height and width. A photograph is a product of your camera lens's focusing on a point within a single two-dimensional plane. But the third dimension may be suggested through manipulation of color, lighting, subject position, and camera angle.

Selective Focus

"A sharply focused subject is considered desirable, if not mandatory, in good photography." In many cases that old adage holds true, but not in all. The human eye and brain conspire to construct images with apparently unlimited depth, but this is not so with the camera lens. Unlike the eye, the mechanical lens can only focus on one spot in a two-dimensional plane. Anything in front of or in

By selecting a camera position to high-light the main subject, the photographer suggests the third dimension otherwise lacking in a photograph. Photo by Marc Levey.

back of that plane is not strictly in focus. Thus, you can choose to focus on any one of a variety of planes for the same scene. You can focus to emphasize the foreground, a middle field, or the most distant objects, and you will produce three radically different perceptions of the "same" subject. You can also direct your viewer's attention to whatever you consider to be most vital in the picture; one face in the crowd or one tree in a forest. Some variation is possible, of course, as will be discussed below (*depth of field*).

Lenses (35 mm Format)

Our eyes, when focused on a given object, have a field of vision of almost 140 degrees. The moving eye covers about 180 degrees. Naturally, everything within its field of vision is not equally in focus. Also, the eye can only discern colors and shapes within an angle of 50 degrees or so, 20 degrees for absolute identification. What the eye identifies in a given situation differs considerably from what the camera lens will record on film, since the camera lens's *angle of view* is fixed and determined by its focal length.

The angle of view, as we define it in this context, is the angle or sweep covered by an optical instrument, whether natural (the human eye) or mechanical (a camera lens). The

The middle ground is the only area in focus in the photo. This result is very different from what it would be if you focused on the foreground—even though the two photographs would still be of the same subject. Photo by Marc Levey.

point to remember is that while the eye is capable of varying its angle of view, camera lenses of specific focal lengths—such as 50 mm or 200 mm—have fixed angles of view. (Unlike our eyes, camera lenses have no capacity for peripheral vision.) Further, even though a lens of a certain focal length may simulate the eye's angle of view fairly accurately (50 mm), and other lenses may represent various objects in a scene in correct sizes proportional to one another (85–90 mm), no single mechanical lens can perform both functions.

Since the total coverage of a set-focal-length lens is expressed as a fixed angle, we are forced to employ lenses of different focal lengths if we choose to include greater or lesser areas. Camera manufacturers have reacted to this need by producing the so-called "interchangeable lens" camera body.

As was mentioned above, the angle of view directly relates to the *focal length,* expressed as a physical measurement such as 35 mm, 200 mm, and the like. The shorter the focal length, the greater will be the angle of view, and the smaller will be the image that appears on the film. Conversely, the longer the focal length, the narrower the angle and the larger the image. For example, when the focal length is doubled, the angle the lens covers is reduced by one-half, but the size of the image is doubled on

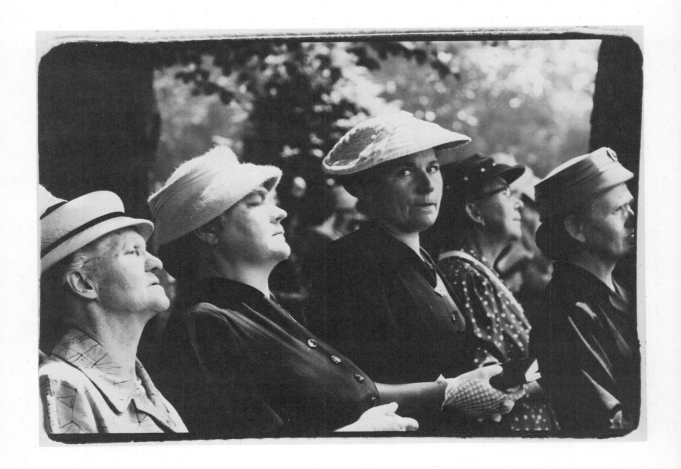

the film. It is important to note that when a lens is replaced by another of a different focal length, not only will the angle of view and image size be altered, but also the *perspective* and *depth of field* will change.

The term *perspective* refers to the relationship between different objects at different proximities: A distant object seems smaller than it actually is, while a close object appears larger than it really is. When you use a wide-angle lens, the perspective is more exaggerated. This becomes increasingly apparent as the angle of view becomes more acute; with a telephoto lens, perspective is all but lost as the focal length increases.

Technically speaking, a camera lens can be focused accurately only on a single point on one two-dimensional plane at a time, as explained earlier. But in actual fact, that focal point's immediate foreground and background can be sufficiently sharp to be *perceived* as being in focus. This zone of acceptably sharp images, the *apparent focus range* surrounding the actual focal point, is the area or field our minds accept as "in focus."

If you choose to convey a sense of space and depth in a case where the scenic elements share equal importance, your photo should contain great apparent *depth of field* with each compositional element looking equally sharp.

Left. This candid view of a "Sunday Afternoon on the Rhine" was taken with a 50 mm "normal" lens. Photo by Bill Coleman.

Below. A 200 mm telephoto lens brings the viewer close to the subject in this in-flight photograph. Photo by Marc Levey.

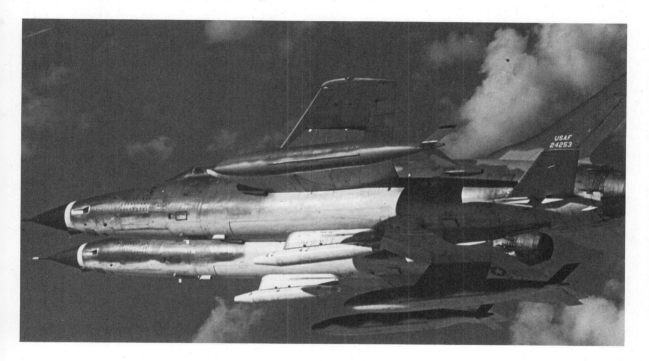

This depth of field is determined by three variables: the selected aperture (*f*-stop opening), the distance from the subject in actual focus to the film plane, and the focal length of the lens in use. Depth of field can be defined as the measurable area of sharpness in front of and behind the subject being focused on.

To increase the depth of field, either choose a smaller *f*-stop or increase the subject-to-camera distance. Suppose you want to recreate the vastness of the Grand Canyon. You can manipulate your shutter speed and lens opening to allow you the greatest possible depth of field, say 1/125 sec. at *f*/11. If you want to isolate one knotted pine tree in that expanse, you might choose an *f*-stop–shutter-speed combination that yields a shallower depth of field, say 1/250 sec. at *f*/4, thus drawing the viewer's attention to that tree.

Inevitably, you must be the one to choose your particular emphasis and manipulate your equipment accordingly.

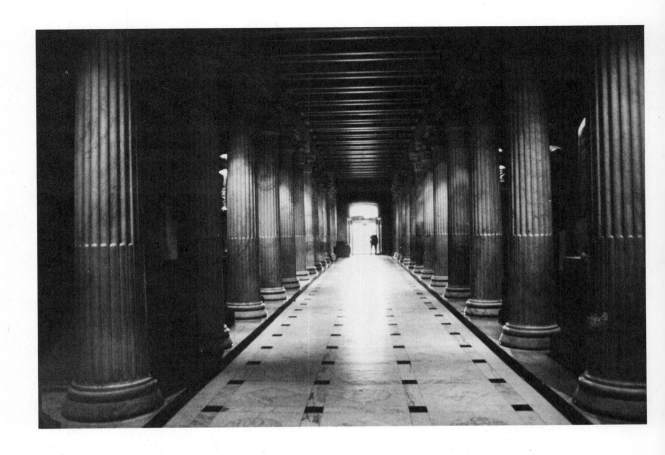

Above. The great depth of field made possible with a 28 mm wide-angel lens lends an impressive aura to this hallway shot. Photo by Samuel Kazdan.

Right. Here you can see what a change in angle of view does to your subject matter. The camera position remains unchanged; only the lenses used are different. Photo courtesy of Canon, USA.

As this discussion has been brief, you may wish to review the lens section in Book One, Chapter I, dealing with equipment, for a more detailed analysis of the different focal lengths and how each lens can be used.

Previsioning

This discussion is predicated on the belief that the photographer's obligation is to guide his viewer's attention to what he feels is most important. Selective focusing can help determine what message your viewer receives, but there are other techniques to consider, as well.

As you observe the subject through the viewfinder, you must make conscious decisions about how you will render it in terms of the film, the camera, and the light. For most of us, these thoughts do not come automatically from our relationship to our cameras the way the genie comes forth from Aladdin's lamp. The

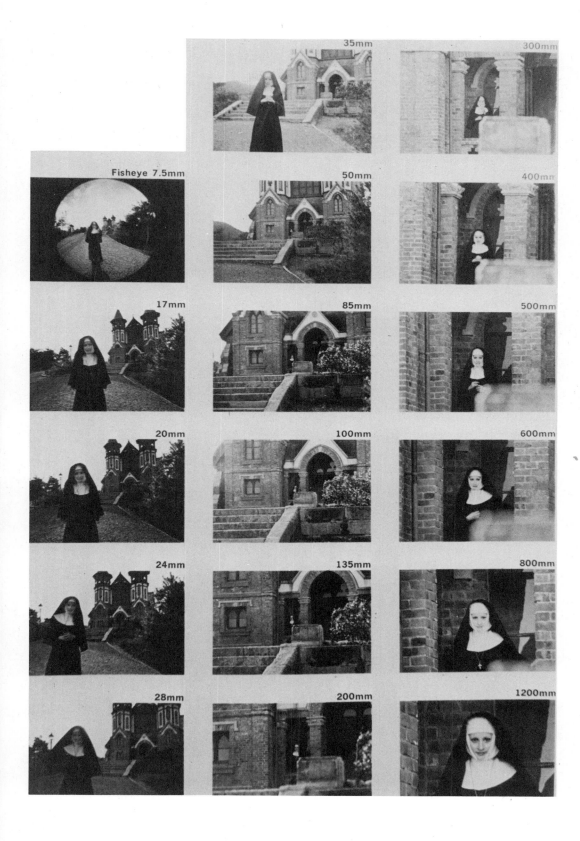

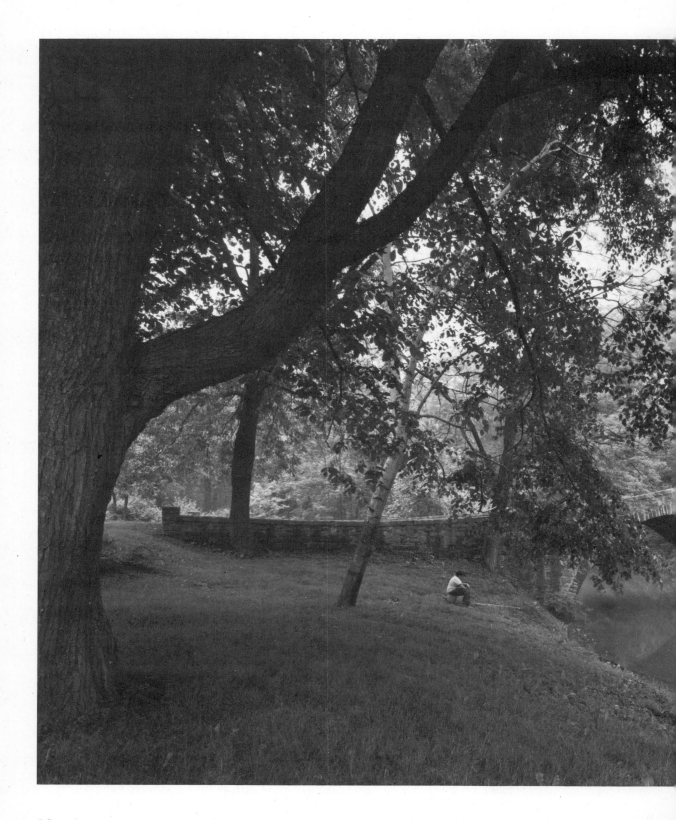

This striking photograph possesses nearly the same great depth of field that human vision gives each of us. Photo by James Lukens.

balance of these elements satisfying to one person may seem off-balance to another. *Previsioning,* the art of perceiving what your mind sees and translating that image onto film, cannot be taught to anyone, since it necessarily is subject to each individual's preferences and learning abilities. We can, however, tell you the questions you should be asking yourself about composition before you shoot.

1. What do I want this photograph to say to the viewer?
2. How do I translate what I see in my mind's eye onto film?

It's true that photographs are manipulations of technical elements, and in that sense the art of photography is considered by some of its critics to be merely mechanical. But that criterion does not make taking a photograph any more mechanical than painting a Van Gogh. Just as the painter must "translate" his oil colors onto a canvas to capture a *Starry Night,* so must the photographer consider his "vision" of reality in terms of its technical parts before the camera records any of it on film. The difference between the photographer and the painter is that the camera records the artist's vision in an instant, not in a series of brush strokes or ink sketchings.

Right. Emphasis is shifted to the foreground in this photograph because the background is less in focus. Photo by L. P. Greenhill, F.R.P.S.

Below. Photographing the subject from a distant point can confuse the viewer as to where the emphasis lies. Where is the main subject? how do you know? Photo by Marc Levey.

Above. Changing the subject-to-camera distance by moving in to fill the viewfinder with the main subject emphasizes the importance of facial features. Photo by Marc Levey.

Balance of Masses

To continue the analogy of painting: The painter first blocks in his basic shapes, but the photographer does not begin with a blank canvas. Rather, he has a concept of the scene already in mind and is weighing the effect of mass on his chosen subject matter. Generally, the scenic element possessing the greatest physical mass attracts the viewer's attention and tends to dominate the photograph. But brightness variations can shift the viewer's focus to physically smaller but more eye-catching objects.

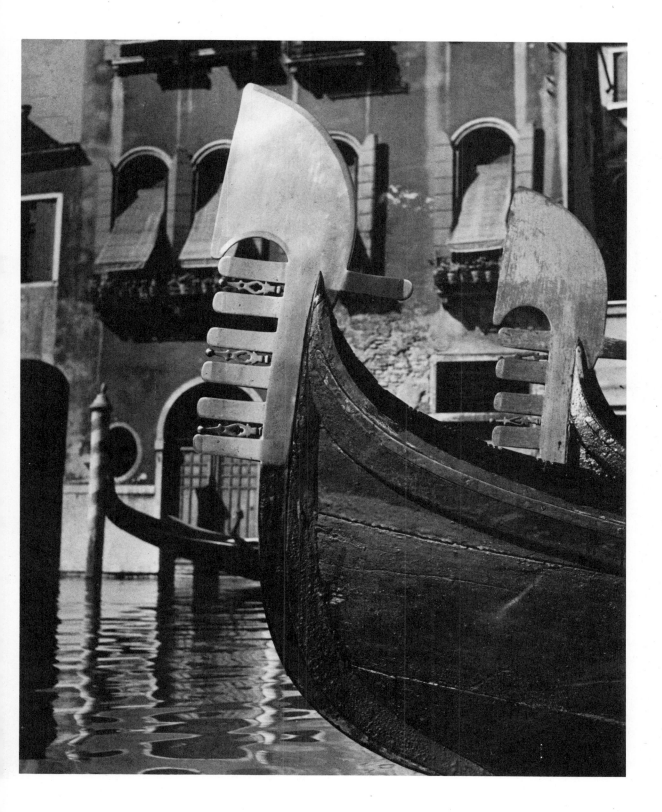

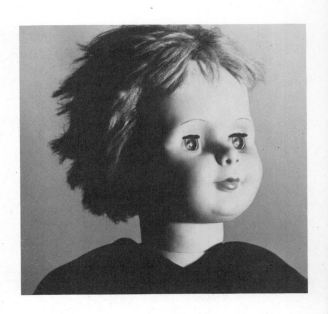

Misplacement of the larger parts in a scene can also ruin a photo by overpowering smaller but more significant details. To some extent, you can switch the tables on the natural effects of mass.

1. Use lenses of different focal lengths (such as a telephoto lens) to compress and de-emphasize large but insignificant masses in the scene.
2. Change your camera-to-subject position. You can also use the above principles in reverse to de-emphasize the relative impor-

tance of a particular object by photographing it from a distant point.

The farther-off objects in photographs tend to look more as our own eyes see them. Thus, focusing the viewer's attention on a single element, as is done in close-up photography, can distort what our minds expect to see. Distortion of mass can be useful; but be careful of it as you work with different lenses, and consider camera-to-subject distances. Remember that the wider the angle a particular lens covers, the greater the danger of distortion—especially in the close-up range.

MOOD CREATION

The content of a photograph alone may not evoke any particular mood. Let's consider mood as a function of three concepts that you can manipulate.

(1) *Mood* can be implied by the range of contrast in a setting. A crowded amusement park in broad, bleaching sunlight is totally different in mood from the same scene deserted

and drenched in moonlight. You can photograph a scene using different exposures, from darkening it overall and creating a sober feeling that requires scrutiny for detail, to lightening the mood and de-emphasizing the finer details. By changing the exposure time and the film, you can make one view elicit many different impressions. Using different films can alter

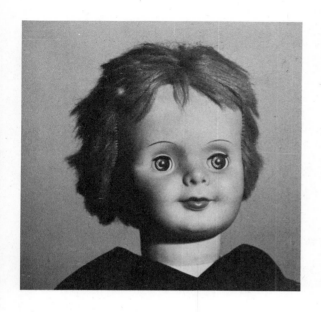

It only takes a slight shift in the position of the subject to alter the mood of a photograph considerably. How does your reaction to the doll differ from side-lit three-quarter view to silhouetted profile? Photo by Margaret Williams.

the quality of the color and the grain and sharpness of the image. (For more on film types, see *Photography: Buying, Choosing, Using,* Chapter IV.) Experiment and see for yourself how variations in contrast can create different moods.

(2) The *position* of the subjects in the picture can alter the mood conveyed in your photograph. Take a profile, a full-face, and a silhouette of a person. Does each perspective produce the same subject? In a sense, yes. But each of these portraits looks different and no doubt brings about a varied response in the viewer.

The location of physically important objects can and usually does make a difference. Sometimes subject arrangement is out of your control, though. Trying to photograph animals in a zoo limits your options; but in other cases physical composition becomes a matter of choice, as when you are shooting a still life where you can arrange the subject matter according to your own preferences. Sometimes you have to take things as they are and make the best of them.

(3) *Color* is another useful tool for creating desired moods. It may be used to under-

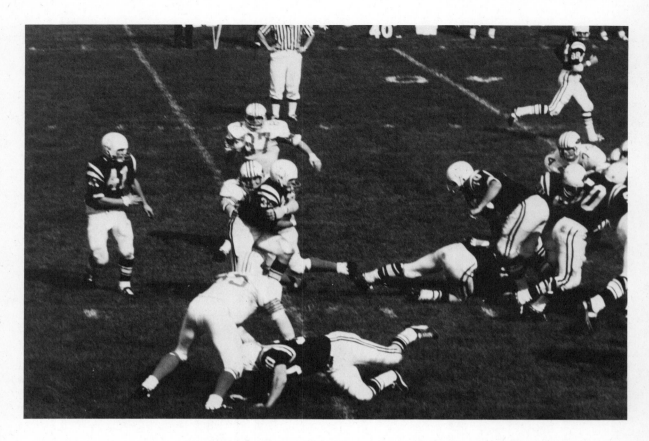

The intent of this photograph is as difficult to pinpoint as the main subject. Photo by Marc Levey.

score, on the one hand, or to create disharmony, on the other. Using warm golds and rosy tones in a still photo of a nude woman and child might imply the photographer's feeling of tenderness and evoke a similar sensation in a viewer. The same scene tinted with a cold, bright green could mean something entirely different.

Taking a funeral scene and casting a yellow aura around black clothing and a desolate cemetery plot can create a sense of disharmony or anxiety in the viewer. Since a funeral normally presents a tense, black-dominated, sorrowful scene, the incongruous use of warm, sunlit colors is likely to produce a mood unlike the one that would be evoked by a black-and-

white photo. The viewer might interpret the color choice to mean hope of religious salvation or, perhaps, a mockery of the mawkishness and expense of today's funerals. The interpretation is not important. What counts is that the photographer can say something personal with his use of color.

Color used to emphasize or to create disharmony probably ought to be subtle; at the least, it ought to be used with discretion. Not all incongruities are significant, and too many in a photograph may be distracting; so consider the use of color as a means to an end. Color for color's sake is not always desirable (see Chapter II for more information on color as a compositional tool).

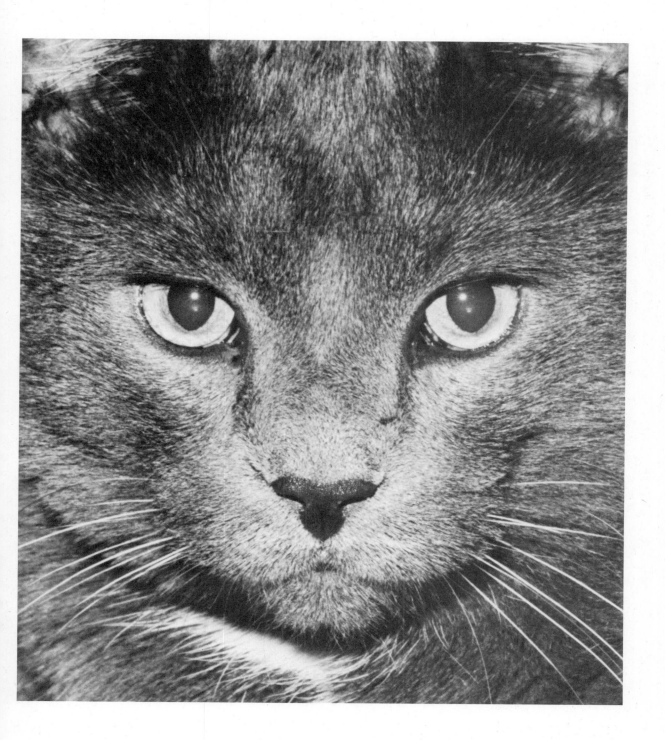

"Bismark" is a good example of the simplified subject. We know what's important! Photo by John Mertz.

"Spectators" draws upon a dynamic pattern of parallel lines to transfer the excitement of the playing field to the sidelines. Photo by Bob Baumback.

SPATIAL RELATIONSHIPS

It is generally advisable to simplify the number and placement of your scene's physical elements. If you can remove nonessential objects that might reduce the impact and meaning of your subject, go right ahead. Most photographers use the following guideline to help define spatial relationships: *Fill the viewfinder with the most important objects in the scene.*

Form

The form of the components used in your photograph is an important consideration when dealing with the concept of space. Line and shape can be expressed through the six compositional axioms listed below. Look for these forms and use them in establishing the bases for your visualizing and preplanning.

1. *Parallel lines.* These horizontal or vertical images can create strong patterns, evoking a sense of symmetry, order, or direction. You see them everywhere in telephone and power lines, in streetlights, on roads, and in railroad tracks, just to name a few.

2. *Circles.* This category includes semicircles, spheres, and anything round. There are many commonplaces in this class, the most obvious being the sun. Circular forms or arcs make good framing tools, but can also create an expansive feeling.

3. *Triangles.* Wedge shapes are everywhere: in rock outcroppings, intersections of power lines and streets, window glass. Inverted triangle shapes make good vignettes: Use them to frame a central image you wish to emphasize. When these forms dominate a scene, they can elicit solidity and strength.

4. *Oblongs.* This division includes squares, rectangles, and all the in-between shapes that have lines or planes intersecting. You find them everywhere, as in passageways, buildings, and crates.

5. *L-Shapes.* This group comprises incomplete triangles and oblongs and occurs most frequently in

Right. The sense of strength conveyed by the triangular subject is further enhanced by the picture's bold tonal values. Photo by Marc Levey.

Below. The arc of the wall with its surrounding pavement guides the eye through a sweep of space to the central figure in the picture. Photo by Alice Clark.

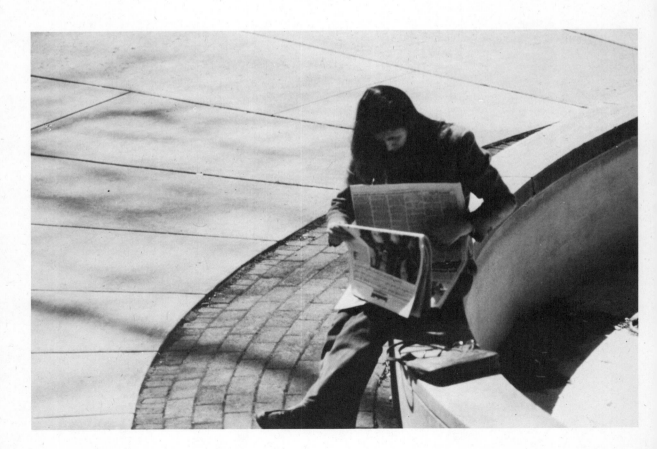

nature. The angles formed by oblongs resting on a horizontal (as buildings do on streets) can be considered L-shapes. They convey strength in the sense of support.

6. *S-Shapes*. All the irregularly curving things on earth go into this category. Think of different-sized circles broken up and rearranged. Rural roads and small trickly streams can be used to illustrate this form which generates a sense of depth, softness, or unhurried movement.

Beyond consideration of these shapes is a concern even more fundamental to the photo-graph's overall effect. The *lines* of these forms relate to the images themselves and to the presentation of the photograph when selecting a mount and frame, as well. Simply put, the prominent lines of your various shapes can set the tone as much as the shapes themselves can influence your composition.

For instance, if a picture contains strong horizontal lines, a sense of strength or spaciousness may be conveyed. Vertical lines, however, may result in a feeling of tension, and wavy lines generally suggest movement to the viewer whenever they dominate a photograph.

Of course, there are infinite numbers of lines and patterns to consider, and discussing them all would be impossible. The important thing to remember is that the viewer's eyes and mind will unconsciously create lines that may

39

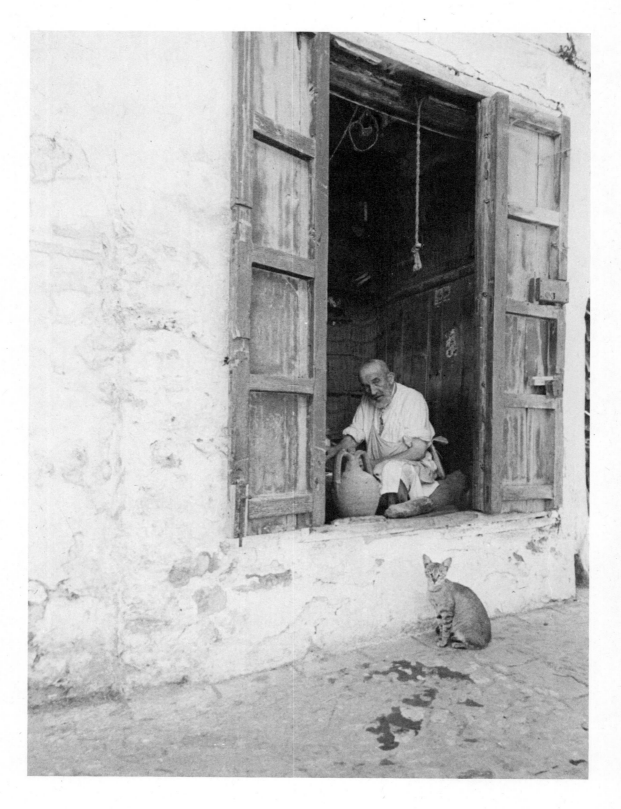

Left. A portrait within a portrait results when an oblong doorway is pressed into service as a natural frame. Photo by Bill Coleman.

Below. The nine-year-old photographer wisely eliminated the distracting detail of cluttered background in this portrait of her grandmother. This is an example of selective focus. Photo by Terry Lukens.

"Swiss Village" bespeaks tranquillity as the viewer's eyes meander along the S-shapes of the road, the shoreline, and the distant hills. Photo by L. P. Greenhill, F.R.P.S.

not be physically present as discrete shapes in your composition. These lines, *whether real or implied,* contribute to the photograph's statement and to the mood evoked in your viewer. Should the pattern or form they create conflict with other compositional elements, your intention may be less apparent and your meaning lost as a result.

Analyzing the scene you wish to shoot in terms of basic forms simplifies compositional decisions. It can make the balancing of masses and patterns more effective. In any case it might help you to think about the geometric parts you have to work with and around. You ought to make it clear to yourself whether you consider all the elements in a scene important or not. If you do not, then you must decide what is most important, so that your viewer can share your understanding. Naturally, you are free to be deliberately ambiguous, which may or may not be worth the risk of being misunderstood.

Use of Space

The rule of thumb in balancing masses is a safe, if a little pedestrian, method of arranging a picture. Divide your scene into thirds horizontally, and then vertically. Usually the intersections of these imaginary lines are visually strong interest points. You can place your

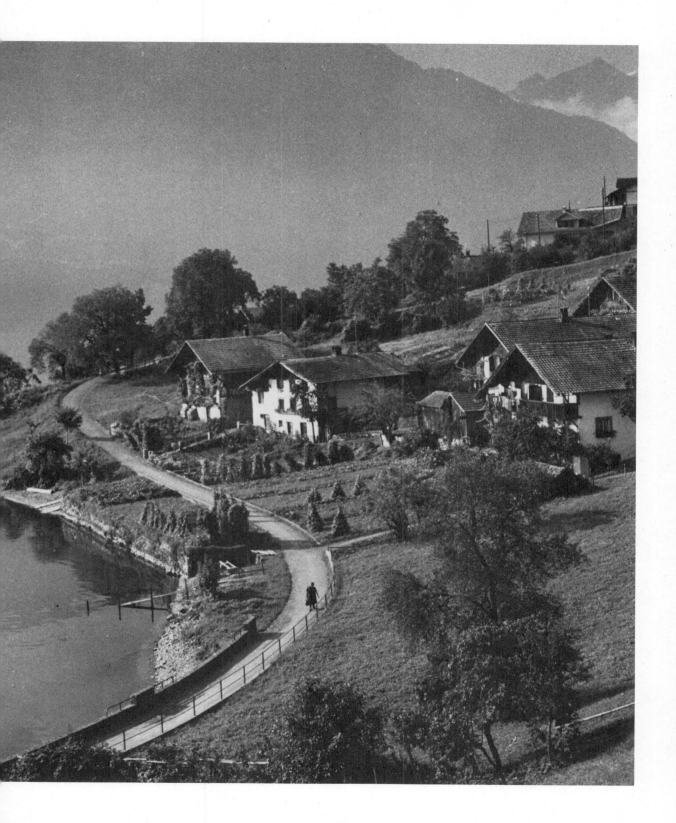

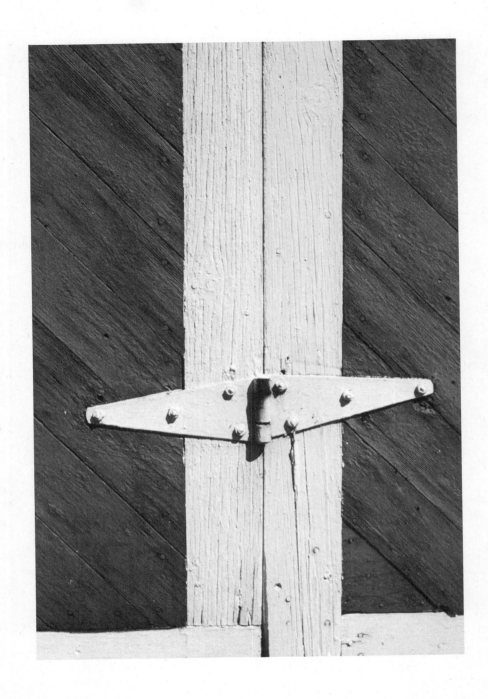

The solidity of both the door and the photograph "hinges" on the L-shaped support. Photo by Marc Levey.

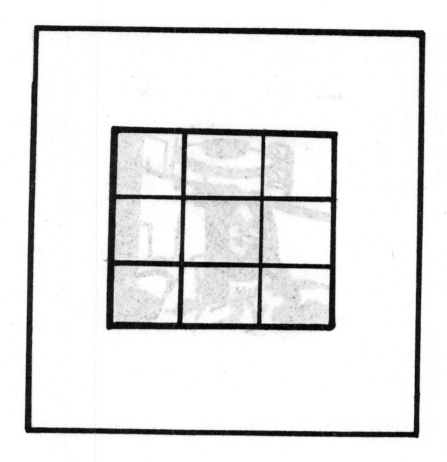

The rule of thirds stresses the placement of the primary subjects along the intersections of imaginary lines that divide your scene—both horizontally and vertically—into thirds.

primary subjects right on, or very near, the intersections.

Central placement certainly puts your main figure in the viewer's spotlight, but it can be rather esthetically "ho-hum."

Centering lends itself to formal shots, such as your great-grandfather sitting stiffly upright in a high-backed chair between two pillars: not terrifically casual, dull, and perhaps even stern.

If a horizontal line bisects your photograph, which is more important: the sky or the earth? The viewer could understandably assume the emphasis to be on both—or on neither—and hope the photographer knew what he or she was doing when the picture was taken. We feel a photographer ought to know what is most significant in his own mind, and that his opinion should be accessible to his audience.

You might try to balance your masses by putting a strong mass on one of your scene's imaginary intersections and another, smaller, one at another intersection.

Panning—the technique of following a moving subject with your camera—is one of the best methods of capturing and emphasizing motion and the excitement it can convey. Photo by David Reasinger.

Avoid placing points of interest on the periphery of your photo. You ought to keep main interests from walking off the edges of your photograph. By the same token, action shots work best if they show movement into, instead of away from, the picture's center.

To draw the viewer's interest to your main subject, try including more foreground than background. If you have a lot of the background in focus, the viewer cannot be blamed for skipping the main item in favor of the distracting details. If the foreground is deep and uncluttered, your subject will emerge to dominate the viewer's attention.

Cropping

The last compositional tool you use should be *cropping*. What you gain from it, though, is rather limited. Cropping does come in handy at several stages: in the darkroom, on the finished print, and when duplicating transparencies. You can also crop in the camera viewfinder by changing your physical position in relation to the subject. Moving closer will eliminate some forms. Moving back will obviously take in more detail.

THINGS TO KEEP IN MIND

Why Am I Taking This Photograph? That's what you should be asking yourself as you prepare to shoot, and if you don't have the answer you are not ready to take that picture.

Fill the Viewfinder. Many beginning photographers do not move in close enough to the main subject. If physical proximity is impossible, try using a longer lens.

Think About the Picture. Think in terms of composition first. If what you see in the viewfinder isn't just what you had in mind, try another angle or another lens before you click the shutter.

What Can I Eliminate From the Scene? Is there anything extraneous that can be physically removed from the photograph? Can you eliminate detracting background by moving in closer or by cropping the subject in the viewfinder?

Is There Depth? Depth is something that gives a photograph an arresting visual quality beyond its subject matter. You can transcend

Experimenting with composition can provide surprisingly numerous variations on a theme. Notice how the different times of the day alter the impression given by the same scene. Photo courtesy of Canon, USA.

the two-dimensionality of the medium by giving an apparent depth to your subject matter—it *is* eye-catching.

Bear the Consequences in Mind. Remember, you cannot assume that the results your camera, lens, and film combination will get are what your eyes see.

Consider Motion. It is good to experiment with slow shutter speeds when you want to convey a sense of motion to your viewer. Sports events provide an excellent opportunity for making use of this technique. Try *panning*, that is, moving the camera along with the object that is in motion. The subject will generally appear sharper than the stationary background, thus implying motion while retaining some degree of clarity.

Aim for a Residual Message. When in the midst of the previsioning process, ask yourself these questions: What is it about this scene that I want my audience to remember? How can this best be achieved both technically and esthetically?

Experiment With Composition. Keep a record of your use of different kinds of composition. If you discover a new or unusual approach

that works well, record it. Maybe you can duplicate it with another subject matter. (There's nothing more frustrating than finding a great technical result and lacking the details of technique needed to re-apply it elsewhere.)

All the above compositional considerations should be thought through if you want assurance in translating your preconceived image onto film. They are basic, vital to the end product you are pursuing, and should become automatic and subconscious after you have taken a lot of photographs.

These guidelines are only starting points in learning the art of photography. Any one of them can be broken. But it is essential that the photographer have a reason for deviating from these suggestions. One good "fluke" is worth much less than several honest tries in any fledgling photographer's attempt to create what he wants to see on film. These concepts will probably serve you well if your aim is to compose good work consistently.

No discussion of composition would be complete without specific mention of content. No matter how technically "correct" a photograph is, it will be meaningless unless there is a content strong enough to convey its message. On the other extreme, the most compelling content can lose its impact and have its mean-

ing destroyed by poor or indifferent composition. Many times the "message" itself will suggest the most effective composition. And that is why we put so much stress on previsualizing: The *method* of presenting your subject matter has more than a little to do with the impact your photograph will have on a viewer. Sometimes a photographer must experiment, shoot several pictures from different perspectives, with different lenses, in different settings, to achieve his goal.

Remember: The content is primary, and all other considerations, both technical and esthetic, take a back seat. Technique and esthetics are ends to a means. They should serve only to reinforce, support, and/or complement the basic message established by the photograph's content.

Once you have achieved consistency between what you envision and the results you obtain, you should then go ahead and experiment. For some further ideas on creative techniques, see Chapter III.

II Color as a Compositional Tool

Most of us perceive our world in color. Further, more than 80 percent of all photographs are taken in color. For these two reasons we will concentrate on color as a compositional tool. But this discussion is not intended to diminish the value and creative potential of black-and-white photography in any way. (The points discussed throughout this chapter are illustrated in the color section of this book.)

Color Accuracy?

The object of using color film, whether negative material that produces a print or slide film that yields a transparent positive, is to manipulate color so that it underlines and emphasizes the basic theme of the picture. If color alone becomes an overpowering force, it tends to defeat the photographer's purpose. What is then created is a *colored* picture, rather than a *color* picture where the hues work in harmony with content and composition.

Many photographers struggle to represent the colors in a setting "accurately." The desire to record colors is quite subjective, since it is very difficult for any two persons to agree on the accuracy of a specific *hue*. There is certainly more than one green hue that most of us are willing to accept as being "grass green."

Most people have little "color memory" to speak of. We may know that stop signs, fire engines, and president's telephones are red, but are they all the same red? Most likely not. The fact is, if we look at that red fire engine for a few moments and 30 minutes later are shown ten different red color samples, we'd be hard pressed to select the patch that exactly matches the truck's red paint. We would have to guess. All ten patches might look correct, or "accurate." The point we're making is that colors are given general names such as "red," "blue," and "yellow" as a matter of convenience. These names actually cover a great many hues that fall into these general categories we accept as the "color." As the hue of a particular color changes, so, too, does the meaning or impression of that color. Knowing that modern color films have distinct limits in terms of their ability to represent color faithfully, we must come to the conclusion that *accurate color rendition* really means *psychologically acceptable color rendition*. We can predict with some degree of certainty how a specific film will reproduce specific colors in almost any situation. However, when it comes to the viewer, we can only hope that these colors will bring forth the desired reaction.

The photographs used as small illustrations in this chapter are reproduced with captions in the color section beginning after page 64.

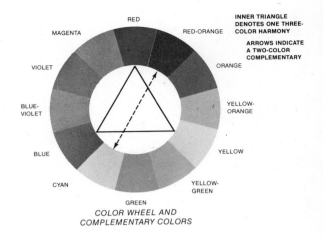

COLOR WHEEL AND
COMPLEMENTARY COLORS

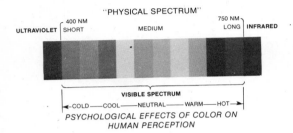

PSYCHOLOGICAL EFFECTS OF COLOR ON
HUMAN PERCEPTION

WHAT IS COLOR?

Our eyes detect light and color through the electromagnetic radiation that exists within restricted limits across the visible light spectrum, approximately 400–700 nanometres (a nanometre is a thousand-millionth of a millimetre). Below 400 nanometres is the invisible ultraviolet range, and above 700 nm is the equally invisible infrared range.

Between 400 nm and 700 nm wavelengths we perceive different colors—for each wavelength, a specific color. For instance, violet and blue are usually labeled "short-wave colors," while orange and red belong in the "long-wave" sector (see color band illustrations in color section).

In addition to this physical description of color, we may also portray the psychological impact of the light spectrum in the following manner: Imagine the bands of light we have been examining bent into the shape of a color wheel (see color wheel illustration in color section). These transmitted colors can be broken down into two classes: primary and secondary. The *primary* colors in photography are red, green, and blue, while the *secondaries* (those produced by combining two primaries) are yellow, cyan, and magenta. Each section on the wheel can be defined as a "hue," that is, a pure

color not contaminated by any other color.

Primary and secondary colors are also important in helping to determine *complementary* colors. Colors are said to complement one another when they appear opposite each other on the wheel.

This wheel diagram shows us that certain colors can be successfully and harmoniously combined, as is the case with complementary colors (green and magenta, violet and yellow-green). On the other hand, those colors adjacent to each other, that is, primaries located next to secondaries (such as cyan and green, or magenta and red) tend to destroy one another's effectiveness. They are difficult colors to work with because in combination they do not present enough color contrast for effective visual separation.

Color Attributes

At this point let's consider the qualities of some common colors.

Red. Red is the most eye-catching and expressive color in the visible spectrum. Great care should be taken when employing red, as it's best when used in small amounts. Reds can be used against light backgrounds, where they

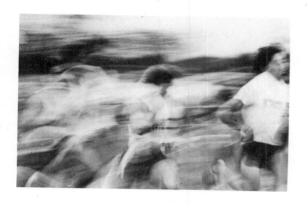

will appear dull and warm. Against dark backgrounds they become violent and alive, evoking tremendous emotion, in hues ranging from blood red to tender pink. Red can be the color of life or of death; it can produce feelings of aggressiveness, anxiety, and sensuality. Red belongs in the foreground. Caution: Even in small amounts, red commands the viewer's attention regardless of where it is.

Orange. There is a wide range of orange hues. Considered a warm and happy color, orange is not as violent as red. On the red side of the spectrum it is the warmest of all colors, producing such shades as fire red. When in shadow, or otherwise desaturated, orange becomes muddy and lifeless. Think of it as a summer or fall color.

Yellow. Yellow is psychologically the most cheerful, being the lightest, brightest, and most radiant of all colors. It is nearer to white than any other segment of the spectrum. It can easily be destroyed by putting colors such as orange, green, or cyan adjacent to it. Yellow blends exceptionally well with blue backgrounds.

Green. This color ranges widely in hues. Green tends to be "cool," but technically it is

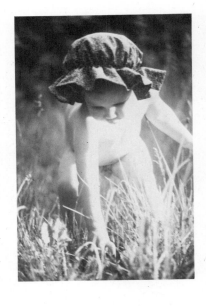

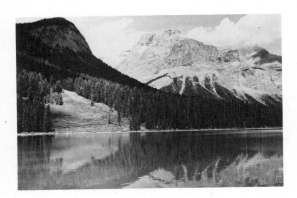

classified as "neutral." Photographers use it in large masses. It is not an aggressive color; however, if used too liberally, it has the effect of dulling a scene. As the most natural of colors, green can represent hope and fertility, as well as bringing forth feelings of solitude and tranquility. It is well suited to detail work, since it does not add too much to content because of its color neutrality.

Blue-Green. This color is often characterized as cold and intrusive, with a relatively small range of variations. It's a good shadow color, and therefore sees little use.

Yellow-Green. Yellow-green has more "body" than pure green, and so gives an impression of warmth. You should be aware that all greens, in whatever combination, are somewhat cold. In scenic photography they pick up the blue cast from the sky, and so are hard to use in foregrounds, as they mute other colors.

Blue. Blue may best be described as a cold, formal, and dignified color that creates an illusion of depth. It naturally belongs in the background. Blue ranges widely in hue, but is easily contaminated by other colors.

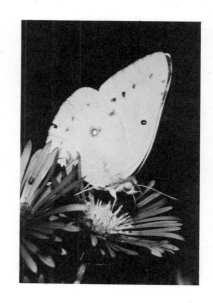

Violet. In a highly saturated state, violet is somber and regal. When it is desaturated, as with the case of lilacs, violet is soft and delicate. Historically, violet signifies royalty and denotes wealth and power. It is also the darkest of all colors. Since it is the closest color to black, it provides an excellent background if well saturated. Few people agree on what is violet and what isn't. Many times it is confused with purple or with magenta, especially near the red end of its range of hues.

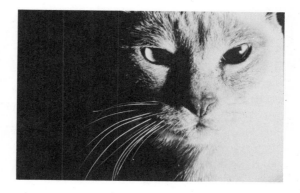

Black. Black is often overlooked in color photography, although it can be a powerful creative tool. Black is hardly ever seen in its pure form; instead it appears as blue-black, red-black, or other combinations. If black exists in its relatively pure form in a scene, it can greatly highlight the other colors. Masses of black in a scene that lacks any well-saturated colors can suggest a death-like effect. Any color can be altered by even small additions of black.

White. White tends to pick up color casts to an even greater extent than black. Since white is the most easily contaminated color, it has an almost unlimited range of hues. (For our pur-

poses, we have chosen to consider black and white as colors.) Even in small amounts, white decreases the relative brightness of other colors, especially those physically adjacent to it in the scene. Pictures with large white masses can be described as "cool", "virginal," "antiseptic," "pure", or "harsh." White is most easily contaminated by blue. White's characteristic ability to lighten other colors should not necessarily be avoided. It can produce a light, airy effect when integrated with other colors.

Gray. Infinite shades of gray lie between the color extremes of black and white. Gray can complement any color, as it is almost completely neutral in the chromatic sense.

SOME GENERAL OBSERVATIONS ON COLOR USE

Now that you have some idea of the attributes of visible colors, we will provide some basic commonsense guidelines that we use in working with color composition and content.

Guideline #1. Beyond the psychological impact individual colors have, we can say that warm colors tend to "project." They thus emphasize the foreground subjects, while cool colors "recede," giving the surroundings a sense of depth or an implied third dimension.

Guideline #2. Complementary colors (review wheel diagram) work well together as long as one dominates in some way. Together they can create an atmosphere of peace and harmony.

Guideline #3. Colors adjacent on the wheel can clash, producing strong—and usually conflicting—emotions in the same scene. For the viewer, the presence of two such adjacent colors in one picture can psychologically eliminate the third dimension.

Guideline #4. Warm colors such as red, yellow, and orange should be used in small amounts. They naturally belong in the foreground. These colors should be used to highlight strong points of visual interest. If you decide to use these in large masses, your purpose for doing so should be evident to the viewer.

Guideline #5. Large masses of several colors in one picture can overwhelm and confuse the viewer. Avoid using more than three colors at any point meant to command the viewer's attention.

Guideline #6. Green, blue-green, and cyan, all neutral colors, are best used in the middle of a scene. Employing these cool colors in landscapes can create a sense of depth, since objects with these shades will naturally recede into the background. In large masses, though, these colors tend to dull a scene.

Guideline #7. Subjects in pictures that have an overall dark (low-key) appearance, such as twilight or low-light shots, seem to recede into the background. Important subjects that have an overall light (high-key) effect, such as in beach or snow scenes and midafternoon shots, tend to project toward the foreground.

Guideline #8. Black masses increase the brilliance of all other colors in a picture, while white masses reduce intensity and seem to desaturate the other colors in a scene.

Guideline #9. The one color in a picture that predominates by virtue of its mass, its brilliance, or its position will set the overall psychological tone for the viewer. Further, since such a color fights to be the center of attention, it must be used wisely or it will overwhelm the content.

THE CREATIVE TRIAD

Color as the Key to Harmonious Content and Composition

When you think about color as a compositional tool, there are four factors to be weighed:

1. The quality of the colors.
2. The physical location of colors in a scene.
3. The way colors relate to each other.
4. The difference between what your eyes see and how the colors will appear on film.

For our purposes, let's concentrate here only on the quality of color and how colors relate.

Color and Exposure Variations

Rarely do we find pure or authentic colors. They are usually admixtures, with one dominant hue. If a pure color is washed out (lightened, desaturated) or dulled (darkened) by another color, it is said to be *contaminated*. Although this term has a negative connotation in other contexts, it doesn't necessarily hold here, since the effect sought might be enhanced by subtly desaturated color.

In general painting terms, a pure color with white or black added to it retains its color identity over a longer spectral range than does a hue that is mixed with a color other than black or white. When white is added to pure colors, it will desaturate and change those colors to pastels; a red chair in a white room will appear less red, for instance. On the other hand, adding too much black can deepen a color to the point where it becomes lifeless and dull.

Photographers, too, have the option of altering the quality of any color—by varying the exposure. As a rule, when working with slide film, overexposure will lighten colors (the same effect as adding white to paints) and they'll become more pastel. Underexposure results in deeper color saturation (the same effect as adding black to paints).

58

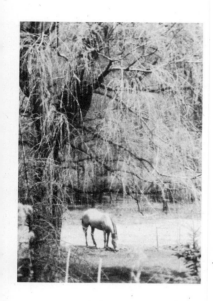

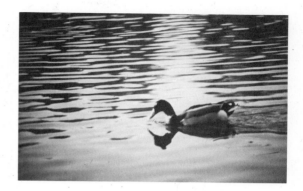

The procedure for exposure variation is reversed when we use negative film; that is, underexposure produces a lighter hue and overexposure yields darker shades. This in-camera process is usually unnecessary, though, since it can be accomplished with greater control during the printing process.

A few words of caution: We as photographers must be content to add to *all* colors or to leave *all* colors alone, unlike the painter who can selectively add black or white to any color he chooses while leaving others more or less untouched, unless we use studio spotlights and other strict controls.

Caution number two: Overexposure and underexposure are strictly limited procedures. When using slide film, you should go no more than two *f*-stops under and maybe one stop over your exposure-meter reading. For negative material, go no more than two stops over or one under. Be aware that this process only works well for low-contrast scenes.

Color hue can be controlled in yet another way. With short exposures—1/60 sec. or faster—deeper color saturation is produced than with the scene exposed at 1/4 sec., 1/2 sec., or slower. At times, this method of controlling color quality is inconvenient. Trying slower shutter speeds to desaturate colors means using a tripod; so it is not practical in all situations.

Color Dominance vs. Color Balance

Thus far we have considered colors on an individual basis. Seldom, though, do we photograph a scene containing only one color (those dedicated to macrophotography will disagree). Let's turn, then, to the subject of how colors relate to one another.

Consider these three particular guidelines:

1. If one or more harmonizing colors stand out, they will set the psychological tone for the entire picture.
2. If one color is much more brilliant than the others in a scene, it will stand out and command the viewer's attention.
3. If there are several colors of equal brightness, they will contend with one another for the viewer's attention.

The question is, how does one color dominate the others?

A color can dominate if it is more brilliant and saturated than the others. It can also take over the scene if it occupies the largest mass, is the warmest color, and/or occupies the area of sharpest focus.

Backgrounds play a large role, too, in determining what colors will control a photograph. Consider for a moment how backgrounds influence color. It is a sensory phenomenon that colors placed against white backgrounds appear less saturated, while those placed against black backgrounds appear more saturated. Backgrounds also affect the apparent size of color masses. An object will seem larger when placed against a black surface than against a white one. To a lesser extent, the same holds true for dark or light backgrounds other than black or white and for warm colors such as red.

A strong contrast is created by projecting a color against a dark background; such a procedure produces visual separation and depth. Light or white backgrounds leave little apparent contrast between the projected color and the background.

Contrasts can also be found when two or more colors in the same scene vary in their relative brightness to one another.

A sense of color contrast can also be produced when one color occupies a greater mass

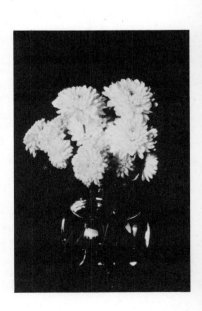

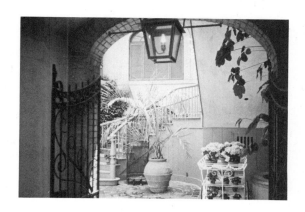

than the others, providing the colors are of equal brilliance. In a situation where one color is significantly more intense or possesses a warmer hue than the others, however, mass becomes subservient.

A good number of photographers capitalize on the ability of colors to dominate. The dominance of colors alone will not always have the desired effect, however. Color needs to be integrated with content and composition to produce a sense of harmony and a well-composed photograph.

Another point to consider is the effect shadows have on colors. Virtually all colors in shadows will be dulled, and thus contrast will be lessened. The amount of the dulling will depend on the density of the shadow areas and on the color itself. Warm colors tend to stand up to shadows better than cool ones. Don't feel that shadows are to be avoided, though; some of the most dramatic photographs are made by using shadows to contrast with the brightness of one or more colors.

Color and Depth of Field

We next touch upon the relationship between depth of field and color. Depth of field is a powerful implement that can be used to create illusions of depth. One thing most photographers don't realize is that depth of field

and color can either work well together or fight at cross purposes.

Those objects in a scene that are in sharp focus and those that are not will largely determine which figures will become the center of the viewer's attention. Color should be used in conjunction with the depth-of-field technique to draw the viewer's eye to the intended interest points. If the major interest is a cool color in sharp focus, it would be self-defeating to place a large out-of-focus warm-color mass next to it.

Color and Natural Light

The following rather general considerations of two phenomena common to natural light are sometimes not taken sufficiently into account by photographers.

First, daylight varies not only in intensity (quantity) but also in color temperature (quality). Obviously, depending on the time of day, season of the year, and prevailing atmospheric conditions, light's intensity will change. More subtle is the effect these variables can have on the color quality of daylight. Natural light is not a constant, and observing dawn, midday, sunset, and twilight only underlines the degree and frequency of change outdoor light runs through daily. Certain subjects might lend themselves to the brightest daylight, whereas romantic portrait or scenic shots might be best

in the softer light of late afternoon.

Second, the sun has a *modeling effect* the photographer needs to consider when planning a shot. The length and shape of the shadows the sun generates around your subject will affect the mood as well as the sense of depth your photo conveys. As a guide, shadows begin long and soft before sunrise and gradually shorten and become more distinct as the sun rises. Around 1:00 P.M. shadows are very harsh and perhaps least attractive in their modeling effects. From that time on they begin to lengthen and soften into sunset.

In summary, the daylight just past noon is the most intense, produces the smallest and harshest shadows, and, in terms of color quality, usually contains a larger portion of blue than the light of early morning (before 9:00 A.M.) and late afternoon (after 5:00 P.M.)

Impact of Film on Color Rendition

It is difficult to predict *exactly* the influences that specific films will have on color rendition. Again, overexposure and underexposure, as well as very short exposure time, can help control color saturations, within certain limits. There are some individuals who go so far as to argue that different *emulsion batches* of the same type and make of film will vary enough in color rendition to make consis-

tently repeatable results impossible. We don't need to be so particular. We do advise you to observe the effects that different sorts of color film (particularly slide, or transparency, film) have on the saturation of colors, especially as they record skin tones. You may want to check the section on film in *Photography: Buying, Choosing, Using,* Chapter III, to review those characteristics that can affect both the color and the impression of the color scene left with the viewer. Of particular concern to you will be the grain, exposure latitude, color rendition, and "sharpness" (acutance) of the film.

"PHYSICAL SPECTRUM"

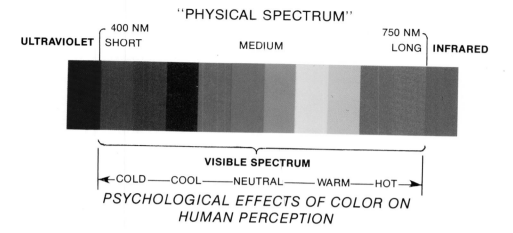

PSYCHOLOGICAL EFFECTS OF COLOR ON
HUMAN PERCEPTION

Visible light ranges from the violet in the 400nm wavelength to red in the 700nm end of the spectrum. Colors possess psychological impact as well as physical properties.

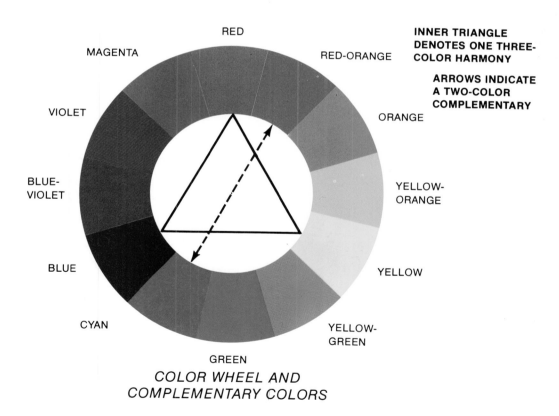

COLOR WHEEL AND
COMPLEMENTARY COLORS

The color wheel shows the relationship between complementary and adjacent colors.

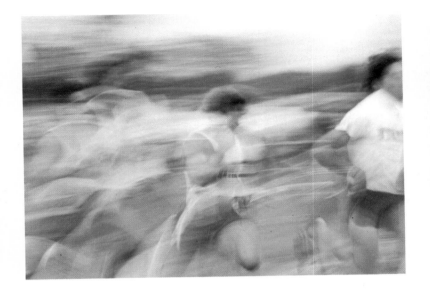

Which blue is the sky? An illustration of the range of hues of any given color. Photo by Alice Clark.

Color alone can become overpowering and self-defeating for the photographer who only wishes to underscore his purpose with its use. Photo by Marc Levey.

Red will always attract attention, no matter where it's located in your photograph. Use it discreetly. Photo by David Reasinger.

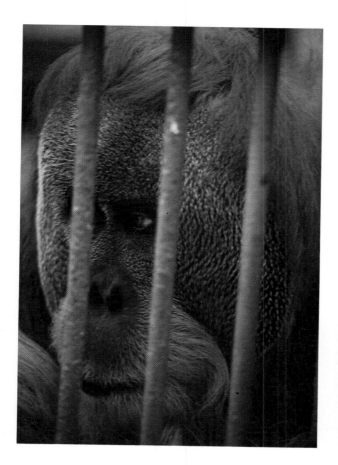

Left. Desaturated orange risks becoming lifeless when compared to its more fiery relatives. Oranges and shadows don't get along well visually. Photo by Marc Levey.

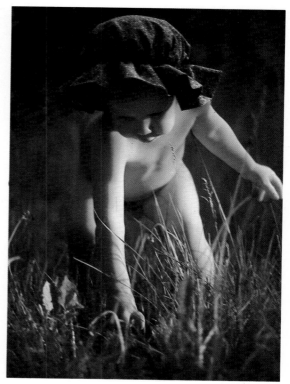

Below. Yellow almost always lends a sunny cast to the subject matter. Photo by Marc Levey.

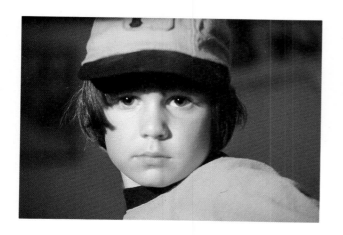

Above. Green, the color chosen deliberately for ''go'' in traffic lights, is the most soothing color to the eye. Photo by Marc Levey.

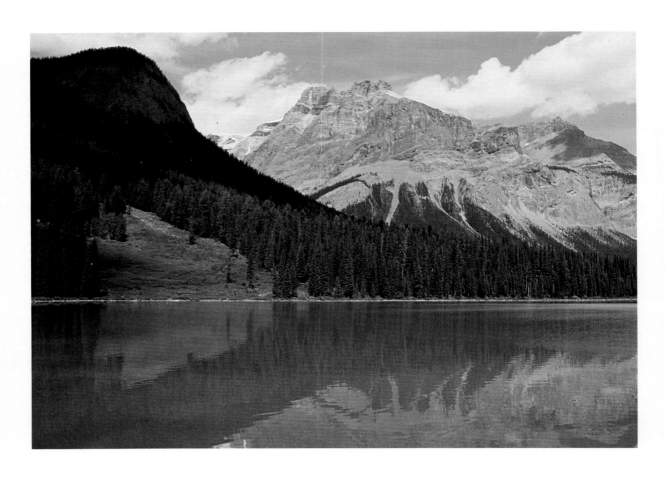

Shadows can best be described as blue-green, which is perhaps why that shade is rarely seen in large quantities. Here, however, they are powerful and they add enormously to the tranquility of the picture. Photo by John Williams.

The risks inherent in using yellow-greens may be worth the warm feeling they can imbue the viewer with. Photo by Marc Levey.

Blue's coldly dignified feeling often comes with an illusion of depth. This color belongs to the background. Photo by Marc Levey.

Well-saturated violet makes a good background color. Desaturated, it can be soft and delicate. Photo by Chandra Swami.

Black, white, and gray in color photography take on an extremely subtle range of tones. Blacks and whites are often overlooked by color photographers but their use can stimulate a powerful response. Photo by Marc Levey.

Warm colors tend to project. Photo by Marc Levey.

Complementary colors work well together as long as one dominates the other.
Photo by Marc Levey.

Adjacent colors can clash, and sometimes their dominance in a scene can
appear to eliminate the third dimension. Photo by Marc Levey.

Large masses of several colors can confuse and overwhelm the viewer. Photo by Marc Levey.

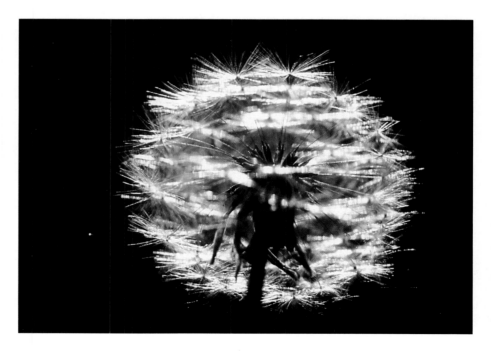

Black will markedly increase the brilliance of any other color when used as a background color. Photo by Alice Clark.

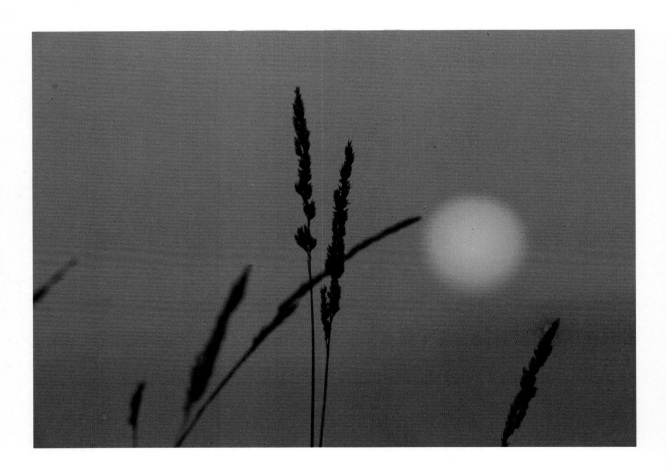

Wisely used color sets the overall psychological tone and underscores the photographer's content. Photo by Alice Clark.

Slide film may be shot at no more than two f-stops under and maybe one over as long as the scene is low contrast. Photo by Dave Reasinger.

Negative material's latitude restricts it to two stops over or one under. But the result is largely dependent on the skill of the printer. Photo by Marc Levey.

The most brilliant and saturated color in a scene will dominate. Photo by Marc Levey.

If the most brilliant and saturated color occupies the largest mass, it will generally tend to dominate the photograph. Photo by Chandra Swami.

An object placed against a black surface will appear larger than the same object placed against a white background. Photo by Tom Sullivan.

Above. Cool colors will make a larger mass in a photograph subservient to a smaller mass of a more intense or warmer color. Photo by Marc Levey.

Left. When two or more colors in the same scene vary in their relative brightness, contrasts will be underscored. Photo by Marc Levey.

Placing a large area of warm color even if out of focus, next to a cool color in sharp focus will usually defeat your purpose for it can be an irritant to the viewer. Photo by Marc Levey.

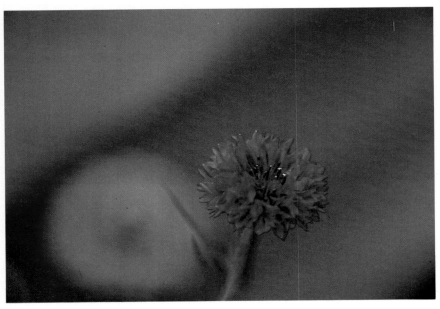

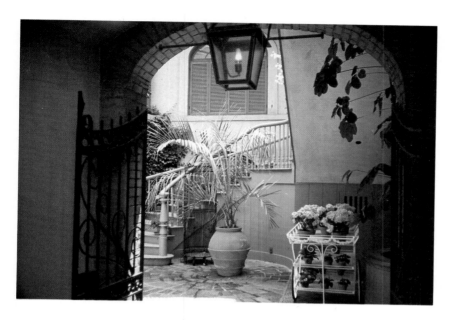

The play of shadows and bright light in a scene will accentuate the natural color contrasts present. Photo by Marc Levey.

Portrait shots profit from the softer and warmer light of the late afternoon. Photo by Marc Levey.

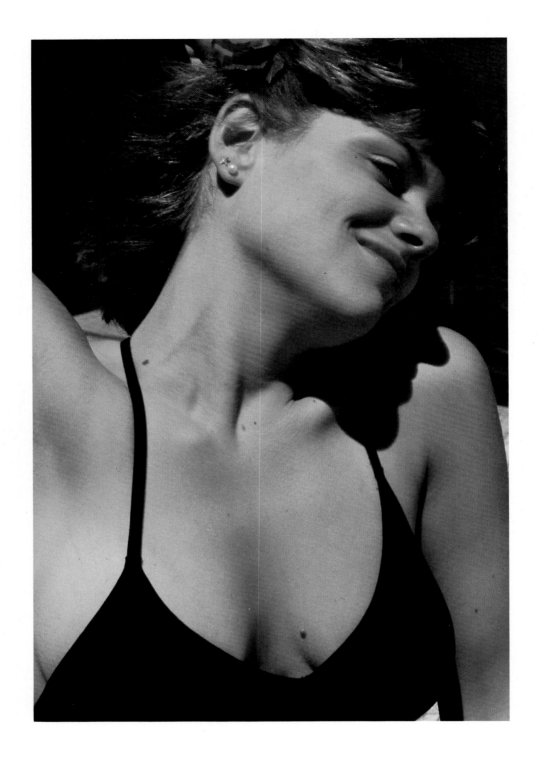

Midday light heightens the harsher aspects of modeling effects. Photo by Marc Levey.

III Creative Effects & Projects

Creativity in photography is the result of four factors. First, you must be willing to experiment: *Don't accept rules as gospel.* Second, let your imagination run wild—the use of large doses of imagination and ingenuity often results in new treatment of familiar themes or in novel picture-taking techniques. Third, be prepared to fail. Catching what seems like an absolutely terrific idea in your mind or even on paper does not mean it can be translated onto film. Fourth, look for the simplest way of achieving your ends. If possible, build things yourself.

Creative photography can present the viewer with a unique and quite personal view of the world which, if executed well, will have *impact*—and that is what good photography is all about.

PHOTOGRAPHY AS AN ABSTRACT ART FORM

Diffusion Techniques

"Diffusion" is a catch-all term describing a wide variety of techniques and resulting effects. It is useful if you wish to create an impression of softness and lightness or if you want to reduce scenic elements to basic shapes and colors, express painting-like qualities in your photographs, or subdue bright colors.

Simple Diffusers. Diffusion equipment can be complex and expensive or simple and cheap, depending on your ingenuity and your pocketbook. Since modern camera lenses are extremely sharp and produce accurate detail, some means of defeating this sharpness must be introduced. The easiest way to accomplish this is to put something in front of the lens. For years photographers have smeared a small amount of *petroleum jelly* on a UV or skylight filter and attached it to the lens. This method works only if you observe the following cautions:

1. Use a very small amount of Vaseline and smear it on in a circular fashion, leaving the very center of the filter clear or nearly so.
2. Gradually work the Vaseline out toward the edges in ever-increasing thickness.

65

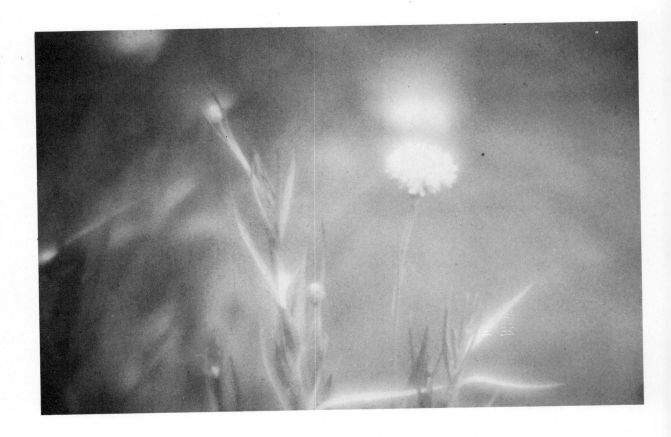

The two unfortunate consequences of using petroleum jelly are that it collects dust and dirt very quickly, so it cannot be used over and over, and that the filter is virtually impossible to clean once Vaseline has been applied. *Never* use it on the lens itself.

Another simple diffusion tool is polyethylene or *plastic food wrap*. Unlike Vaseline, it's a clean process. If you wish you can cut a hole in the center of the plastic and then stretch it tightly over the lens, using a rubber band to hold it in place. The results are similar to Vaseline's, but not as pronounced.

A third diffusion trick is to use a piece of *nylon stocking* in the same fashion as described above. Make sure that you use the lightest color you can find, combined with the finest mesh, and pull it tight.

Soft-focus filters are designed to cut down on sharpness and are available in a number of styles, from random diffusion to specific diffusion of either the center or the edges of the picture. Unless you are going to shoot a lot of diffused-effect pictures, these filters are probably not a good investment as they tend to be expensive (from $7 to $30). On the good side, virtually all filter manufacturers offer these, and they are fun and definitely do work.

Another device that has great creative potential is an *adjustable diffuser* called Pictrol, which retails for about $8.95. Originally intended to be used in the darkroom to diffuse prints, it can be modified to fit in front of most lenses of moderate diameter. Essentially, the Pictrol is a set of clear plastic diaphragm blades in a control ring that opens and closes

Diffusion may be created by using petroleum jelly or plastic wrap over the lens. Photo by Marc Levey.

them in order to achieve the desired effect. To modify the Pictrol, cut the small retaining clamps in the back and recement them to accommodate lenses of larger diameters. (In its original form, the Pictrol can only be fitted in front of lenses five centimetres [two inches] or less in diameter.)

Up to this point we have covered simple diffusion techniques using materials you can find at home, as well as commercial diffusion filters. We want to draw your attention now to a soft-focus lens that you can make on your own.

A Soft-Focus Lens to Make. First order a piece of double-convex glass from the Edmund Scientific Company or a similar outfit you might be familiar with. This glass is usually surplus and of good quality. The glass you order should be at least 90 mm to 150 mm in focal length and 40–55 mm in diameter. It will only focus one area sharply: The rest will appear as light or dense haze. The effects produced are quite unlike any other diffusion or soft-focus device we have tried. In addition, "fog" effects can easily be created using the lens itself.

This do-it-yourself lens can be constructed in either of two ways.

(1) If you own a bellows you can attach the glass by taping or gluing it to the front of the bellows or by using a Series Double Retaining Ring. So that this lens focuses at infinity, the length of the bellows/lens combination when the bellows is compressed must be no more than the focal length of the lens. For example: From the focal plane (designated by the symbol ⊖ on the camera body) to the lens itself is 110 mm. Since the focal length of the lens is 110 mm, the lens should now focus at infinity. Further extension of the lens will focus it on objects nearer than infinity.

The long bellows combination we show is a 95 mm lens calculated to be about *f*/2. Since there isn't a diaphragm, exposures are metered by varying the shutter-speed control on the camera.

(2) Construct two tubes, one fitting snugly inside the other but with enough clearance so that one of the tubes can slide back and forth. (Bathroom-tissue rolls can be very handy for this design.) Again, the minimum length of the combination from lens to focal-plane mark on the camera should be equal to, or less than, the focal length of the glass used. Thus, any old piece of double-convex or magnifying glass will *not* do; you must know the focal length of the glass—the distance needed between the lens and the point where rays passing through it come together, or focus.

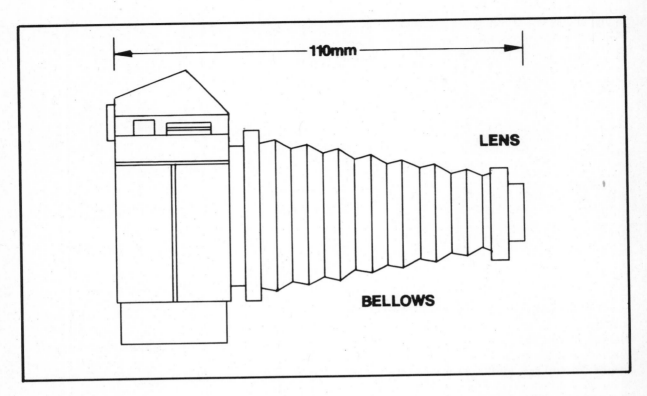

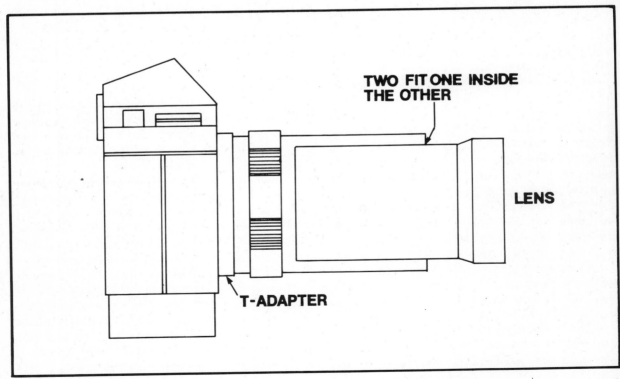

The length of your bellows/lens combination must be no more than the lens's focal length when the bellows is compressed. Diagram by M. H. Irish.

The beauty of this arrangement is that you will always be shooting at *f*/2; so the out-of-focus areas of the picture will be hazy, almost dreamlike, and at *f*/2 fast shutter speeds can be used.

Finally, as in all things that relate to photography, there is a lazy man's way of doing almost anything; so if you choose not to make your own soft-focus lens, you can send for one. Spiratone, Inc., will gladly furnish you with one for a mere $30, plus shipping.

Diffusion by Glass or Plastic Screens. "Impressionistic" images can be created by using a variety of textured glass or plastic sheets between the subject and the camera lens. Carefully photographed flowers, faces, or scenics can have much the same sort of stopping power as paintings do, by reducing your visual impressions to basic form and color.

You'll need the following pieces of equipment for this technique:

1. A piece of textured glass or Plexiglas.
2. A polarizing filter.
3. An SLR camera.
4. A macro lens or other close-focusing attachment (optional).
5. Color film.
6. A tripod (optional).
7. A light source.
8. A tabletop or other convenient support for subject matter (optional).

The glass should be portable (a piece one foot square [30 cm on a side] is ample for us), translucent, and have an irregular pattern. Regularly patterned glass has a more uniform texture and gives less visually exciting results. Textured glass or Plexiglas is generally available in a wide variety of patterns at any good-sized glass shop and in many hardware stores.

A polarizing filter is a must. It helps control the reflections you are bound to get from strong light sources. Polarizers can also add to overall color saturation, rendering your main subject brilliantly against muted, less saturated backgrounds.

If pictures have to be made indoors, special care must be taken with lighting. If you choose to use artificial lighting, the light-source/film combination must be balanced. Most color slide films are balanced for a daylight temperature of 5500 to 6000 K, and therefore will not work well in tungsten (incandescent) lighting situations. Films are now available, however, that work quite well with artificial lighting. Kodak high speed Ektachrome type B film is balanced

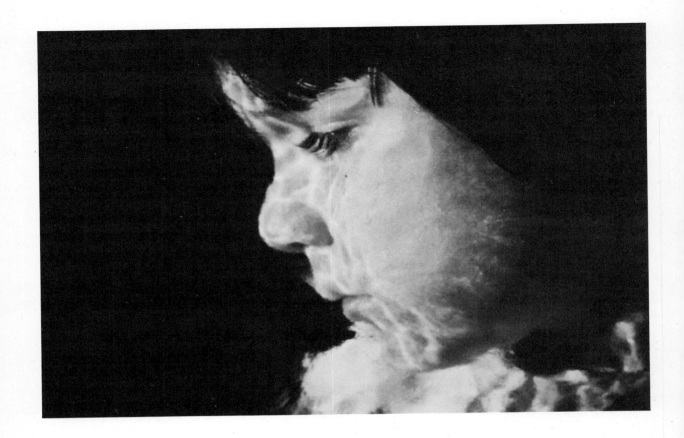

for 3200 K and is the film most closely matched to ordinary indoor lighting. The newer Ektachrome 50 and Ektachrome 160 are also balanced for 3200 K. Another film, Kodachrome 40, is balanced for 3400 K and is normally intended for use with quartz lights. If you prefer using daylight film, it can be balanced for use with incandescent lights by adding a filter: either an 80A (for 3200 K tungsten light sources) or 80B (for photofloods).

Another lighting option indoors is electronic flash. While you won't have a color-balance problem with electronic-flash–daylight-film combinations, the light produced tends to be on the harsh side. One solution is to bounce the flash from a nearby wall or ceiling. Be careful, though: The light produced by bouncing tends to pick up some of the color of the surface from which it's reflected. This can affect the overall color balance of your transparencies. If you don't have white walls and ceilings, you can bounce the flash off a piece of white posterboard.

While lighting indoors is a bit trickier than using daylight outdoors, with a bit of testing you can find several combinations that work well. You may even want to try using daylight film under tungsten light without filtration. Experiment—there's no telling what creative applications you'll discover.

To shoot a tabletop setup, mount your light source (floods or flash) on a light-stand or tripod about three feet higher than the subject and at a 45 degree angle, pointing downward. If you use floods, a diffuser over them can help soften the light.

Photograph taken with a polarizer, using the diffusion-screen technique. Photo by Marc Levey.

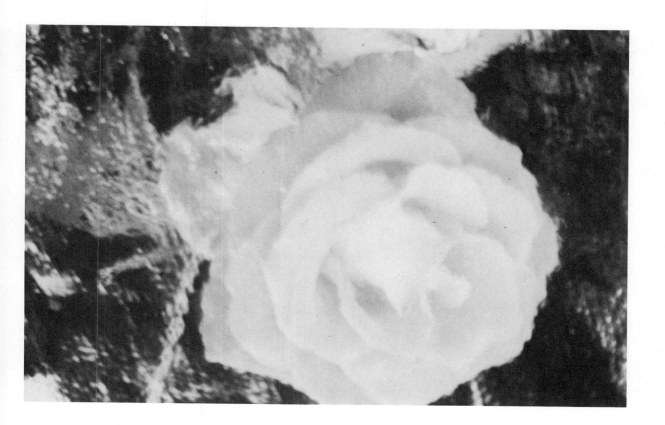

Polarizers will also help control reflections and so are a must with any diffusion method you choose. Photo by Marc Levey.

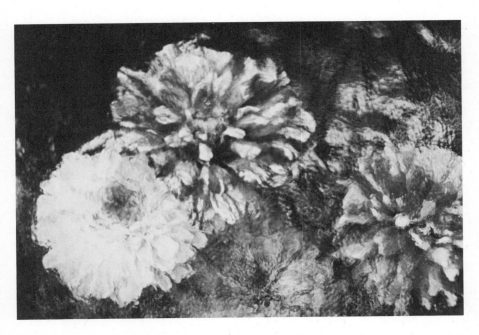

Here a diffusion technique employing a glass screen between the subject and the lens was used in combination with photomicrography film. Photo by Marc Levey.

Don't overlook the potential of natural light or soft open shade. If you have windows with a northern exposure and you can set up near them, the light available there might prove ideal for this technique.

When photographing outdoors, several options enter into your film choice. With natural light, slow or moderate-speed films (Kodachrome 25 and 64, Fujichrome R-100, or Agfachrome 64) work best because they give higher color saturation and contrast. But if you want hazy pastels, you might try a fast film, such as high speed Ektachrome. Kodak photomicrography film produces extremely high contrast and also mutes the background detail; but a word of caution: Photomicrography film varies in both color balance and effective exposure index from one emulsion batch to another.

Clear an area and set up your subject on the tabletop. A blank wall is one obvious background possibility. The foliage surrounding flowers is another; you might want to use a leafy plant to frame a blossom. But remember that you're working with very shallow depth of field, and so there is a limit to what detail will show in the background. Set up your tripod, and your light if you're using an artificial source.

Although you can hold the glass yourself it helps to have a partner. Since the angle from the light to the glass determines the results, you may have to experiment to find the most effective angle. Glare can be a real problem; and it does get a little tricky trying to manipulate both the glass and the camera, but it's not impossible. In any case, you must have a polarizer in front of your lens or *all* you'll get is glare. (See accompanying drawing of the setup.)

The closer the glass is to the subject, the more color saturation you'll get and the sharper the images will look. The farther the glass is from the subject, the more detail-less and "abstract" your images will be. Moreover,

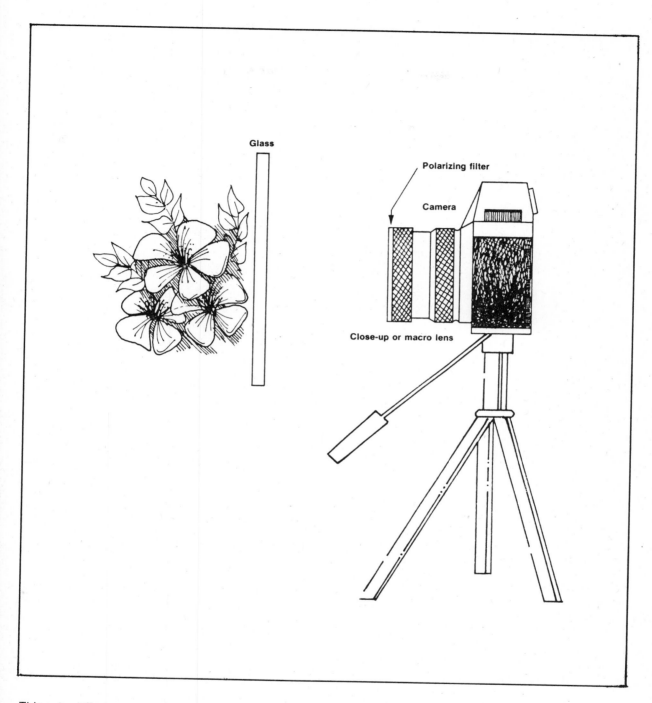

This setup allows you to shoot a subject, such as flowers, through textured glass or patterned Plexiglass to yield an impressionistic effect. The camera, with close-up or macro lens and polarizing filter in place, is positioned securely on a tripod. By varying the position of the camera and the angele of the glass, many different images can be obtained.

Microscopes can be used to create startling abstracts from crystals. Here microscope optics are used in place of a camera lens. Photo by Marc Levey.

color saturation will be reduced considerably. Moving the glass too far from the subject produces indistinct masses of color with very few definable forms, resulting in a too-soft, uninteresting photograph. A glass-to-subject range of 1.2–60 cm (½–24 in.) is a practical working distance. Otherwise, the textured glass will need to be larger to cover the lens's angle of view—and bigger glass is harder to handle and to adjust.

Close-up equipment is essential for many nature pictures. You can use a macro zoom lens in the macro (close-focusing) mode to isolate one flower, frame it in the viewfinder, and shoot it, thus eliminating most of the background. You can shoot some groups of flowers by setting the lens at its minimum zoom range (in this instance, 70 mm), which has the same effect as backing away and thus widening the field of coverage. The beauty of a macro zoom lens is its tremendous versatility.

As you previsualize your shots the variables that need your closest consideration are:
1. How close the glass is to the subject.
2. The distance between your camera and your subject.
3. The degree of polarization.
4. The angle between the light source and your glass.

The polarizer on your lens will save you some fiddling around with adjustment of the glass. The keys to success are experimentation and patience.

Take your time when focusing, so that you can preview the depth of field. Using small f-stops will help insure an overall sharpness; remember, depth of field is critical at these close distances. Experiment with the angle of the glass and with the distance between it and your subject. You won't have to concern yourself with any film graininess because you *want* diffusion to break up your images into portions of color and form. You'll find grain adds a new dimension to the effect, reminiscent of the Impressionist painters.

Diffused Portrait. The rules are roughly the same for portraiture, except that you should pay particular attention to backgrounds: muted foliage or plain backgrounds; work best. Avoid vertical or horizontal lines or patterns. Best results come when the subject holds the textured glass against or near his or her face.

Micro Art (The Easy Way)

Photomicrography is the technique of using the microscope's optics to photograph the minute world contained in a drop of water, or

74

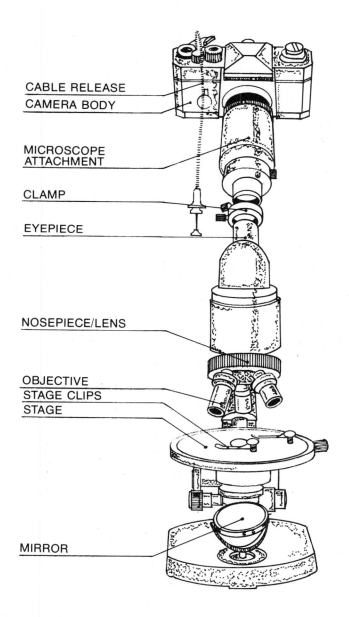

CABLE RELEASE
CAMERA BODY

MICROSCOPE
ATTACHMENT

CLAMP

EYEPIECE

NOSEPIECE/LENS

OBJECTIVE
STAGE CLIPS
STAGE

MIRROR

the geometric forms of a crystal. Although some purists insist that micro art is an exacting and difficult process, our extensive experience runs counter to this opinion. We have developed a method that, while not simple, uses common household objects for the most part.

The most dramatic effects in photomicrography are obtained by photographing crystals. This can be done at home, using the following equipment:

1. An inexpensive student microscope.
2. A high-intensity lamp (fusing car-headlight bulbs) or a slide projector as the light source.
3. A camera-body-to-microscope adapter (adapters are readily available from $10 [Vivitar] to upwards of $30).
4. An SLR camera body.
5. Polarizing material in sheet form (plastic).
6. Crystal specimens.
7. Color slide film (compatible with light source).

Most critical to this process is the obtaining or making of suitable crystals. Largely a matter of trial and error, and frustrating for those of us who are not scientifically inclined, this phase of producing micro abstract art has been simplified by the Student Science Service Company, 3313–15 Glendale Blvd., Los Angeles, CA 90039. This company offers a reasonably priced crystal-making kit that con-

Photomicrography is just one creative technique open to you. Boric Acid. Photo by Marc Levey.

tains everything necessary to produce crystals for the microscope. Included are detailed instructions and ample supplies of chemicals, such as potassium ferricyanide, potassium chromate, sodium nitrate, urea, and other specimens that work especially well.

If you so choose, you can purchase microscope-ready crystals mounted in 25 × 25 mm (2 × 2 in.) glass mounts from the Edmund Scientific Company for less than $15 for a set of five. Order #41381 or #41382; the address is Barrington, NJ 08007.

Let's assume you've assembled your equipment and have crystals ready to go. Now you have to consider the film you will need in conjunction with the light source you want to use.

Since you will be working at extreme magnifications, a fine-grained color transparency film is essential. Kodak markets a photomicrography film especially designed for this type of work, but it's not generally available in local camera shops. We've used Kodachrome 25 or 64 for low-contrast subjects and Fujichrome R-100 for higher-contrast subjects. Remember that daylight color films such as these only produce accurate colors when matched in color temperature to the light source; so, if you use your slide projector as a source you will need to use an 80A or 80B filter. A projector's light is in

the 3200–3400 K range and daylight color film is 5500–6000 K. You could also use a tungsten-balanced color slide film, such as Kodachrome 40 or Ektachrome 50 or 160 tungsten.

In any event, playing around with different combinations of lights and film types is part of the fun in this technique.

Step-by-Step Procedure

(1) The first thing you will notice is that the crystal specimen is only a milky white glob until you place a piece of polarizing material on top of the specimen and then sandwich another piece of polarizer on the bottom of the crystal. It takes both pieces to polarize light. Rotating either one will produce a dazzling array of colors and forms. Notice how the colors change as you change their orientation to each other. Maximum effect is generally produced when the polarizers' axes are crossed (note that polarizers, by definition, only transmit light in one direction). This phenomenon is called *chemical bi-refringence* and is what makes the colors visible. When you get the pattern-and-color combination you want, tape the three layers together. Your specimen is now camera-ready.

(2) Set up the microscope on a sturdy table. It's best to place it on a heavy rubber or

Vitamin C. Photo by Marc Levey.

foam pad to minimize camera vibration.

(3) Attach the microscope adapter to the camera body and then to the microscope.

(4) Direct the light from the source onto the microscope's reflecting mirror in such a way that light is beamed evenly across the viewing screen. It might take a bit of fiddling to position the light source, but it's important to get even light distribution.

(5) Place the crystal sandwich on the microscope stage and "fine-tune" the light source. Start out with the microscope's lowest power setting (generally 20–50×). Focus the microscope so that the specimen's edges look sharp. Slowly move the sandwich around until you find the section you wish to photograph, and then use the springs on the stage to hold it in place.

(6) Use the camera's behind-the-lens meter to determine proper exposure. Remember, the only control you'll have is the shutter-speed dial. (Built-in aperture-priority automatic exposure meters will still work automatically in this setup.)

(7) If your camera is equipped with a mirror lockup, use it. Anything that decreases vibration will help. Now, using either the self-timer or a cable release, gently make an exposure. For added insurance and to see differences in color rendition you can take two additional exposures, one stop over the meter setting and one under.

(8) Some additional hints: Most crystals are complex structures, yet the best graphic results come from strong forms and colors rather than from a jumble of forms, shapes, and varied colors. So search for strong patterns and harmonious color combinations.

In the Kodak publication *The 10th Here's How* is a detailed discussion of photographing crystals (pp. 119–136). The book can be obtained from local camera shops.

2¼"

18–24" LONG

Constructing your own prism device is a simple matter.

Creativity With Prisms

To achieve multiple images, you can construct a prism like the one illustrated. To keep it as lightweight as possible, use foam-core or heavy cardboard for the sides. Have the glass shop cut three pieces of ⅛-inch-thick mirror, each 6 × 46 cm or 6 × 61 cm (2¼ × 18 in. or 2¼ × 24 in.). Cut cardboard the same size. Glue the glass to the boards and assemble them into the prism shape, using cloth or reinforced ("gaffer") tape. A variety of effects can be achieved, depending on the main subject's distance from the front of the prism.

A student in a class taught by one of the authors went so far as to attach a tripod socket to the base of the prism with epoxy and then mount it on a tripod.

The important thing to remember about shooting through a prism shape is to get the front of the camera's lens as close to the prism as possible.

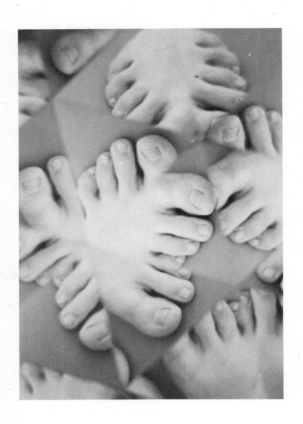

Left. The most ordinary subjects become fascinating when viewed through a prism. Photo by Joseph Bodkin.
Below. To emphasize the unusual distorition created by a prism, the photographer filled the frame with a close-up of the subject. Photo by Marc Levey.

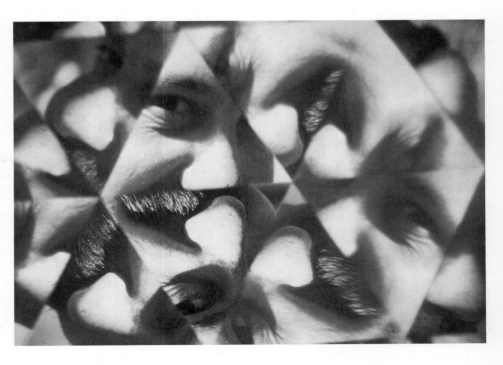

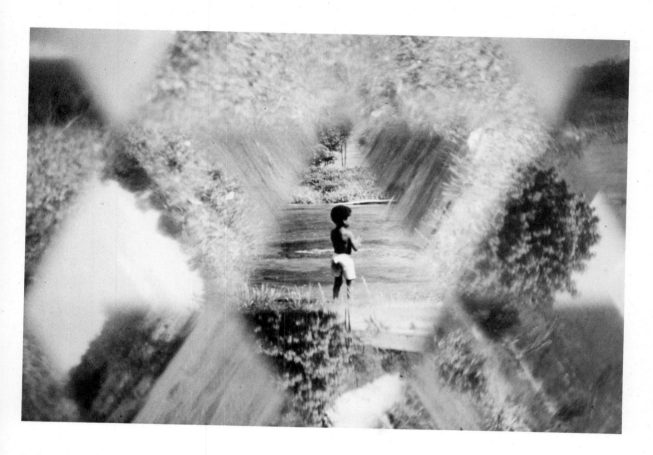

A distant subject that might easily have been lost in a "straight" photograph captures the eye and the imagination in this prism-made shot. Photo by Marc Levey.

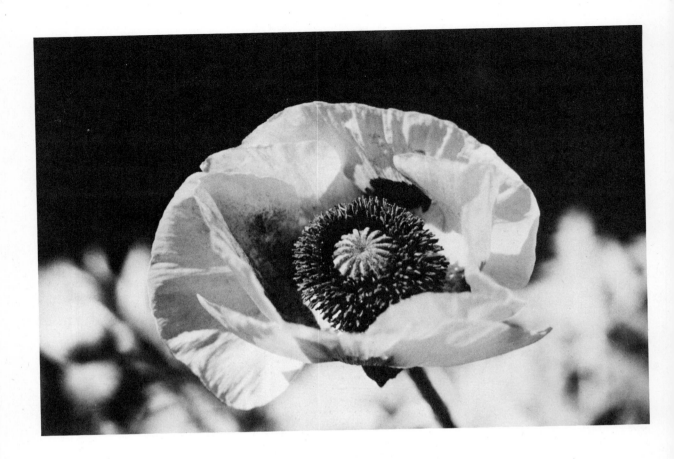

A Proven and Repeatable Close-up Technique

There are two things about close-up, or macro, work that tend to lead to disappointing results for many photographers.

1. The exceedingly shallow depth of field available for photomacrography dictates the use of very small *f*-stops and, thus, slow shutter speeds.
2. Even the slightest vibration can cause poor picture quality, and so hand-holding cameras for extreme-close-up work is not a good idea.

Using the procedure outlined below, however, you will be able to do macro work at small *f*-stops and fast shutter speeds, even with a slow color film such as Kodachrome 25. Sounds impossible, doesn't it? It isn't when we recall the properties of electronic flash.

When working at very close distances, let's say 15–25 cm (6–10 in.), a flash will fire for only a very short time, 1/1000 sec. or less. This extremely short flash duration works to your advantage in three ways: It freezes the subject, even a leaf in a mild breeze; it allows for a relatively fast (up to 1/125 sec.) shutter speed combined with a small *f*-stop (*f*/16) with its great depth of field; and last, the process is repeatable from subject to subject because electronic flash is predictable and constant, assuming fresh or fully charged batteries are used each time.

Photograph taken with a foolproof close-up technique. Slight side lighting enhances rendering of textures. Photo by Marc Levey.

The essential thing in this system is to keep the flash head even with the front of the lens, pointing it at a 45-degree angle. If the lens is refocused and therefore moved toward or away from the subject, the flash unit must also be moved. In other words, *the relationship between the flash unit and the front of the lens must always be the same.*

There are devices like the Novoflex Macro Flash Adapter or the Spiratone Twinlight Macroadapter that can maintain this relationship mechanically. These devices are rings that screw onto the front of the lens and have two extension flash mountings that swivel to position the flash exactly where you want it. If you don't want to invest in such equipment ($20–$30), careful handling can accomplish the same thing.

Calibration of the lens f-stop–flash-setting combination is an easy matter. Set your flash to "manual" and then set your lens's f-stop to f/16; shoot one exposure. Then wrap two layers of paper handkerchief or lens-cleaning tissue over the flash tube, holding the tissue in place with a rubber band. Make another exposure. The third exposure should be made with 4 layers, the fourth with 8 layers, the fifth with 16 layers, and the sixth with 32 layers. Carefully note which picture-number goes with which tissue-and-flash combination. Examine the resulting slides and determine which one gives the best exposure.

Your unit is now calibrated and will deliver consistent results at magnifications ranging from a bit more than a quarter life size to a little over life size (1:1). The advantage of this technique is that once your flash-and-film combination is calibrated, it can be used again and again, regardless of the lighting conditions available (no more waiting for the "right" light). Further, 45-degree lighting will enhance the texture of the subject matter, so that you should get some beautiful results.

If you own an automatic flash with multiple f-stop choices, you may wish to use the auto feature by selecting the power setting that will allow you to use a small f-stop. Take one exposure at that setting, then a second at one stop smaller, and a third at two stops smaller. If you are still getting too much light, try shooting another series of slides, setting the flash in auto mode and the f-stop at f/16, but with two to four layers of tissue over the flash tube. Keep adding layers of tissue until you get the desired exposure.

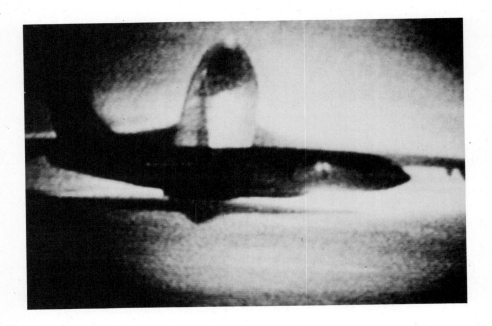

Photograph of a color TV image (converted to black and white). Photo by Marc Levey.

A Grab-bag of Ideas to Whet Your Creative Appetite

Multiple Exposures. On many cameras, especially the new 35 mm SLRs, multiple exposures are easy. On others it is more tedious and less precise, but still in the realm of possibility. If your camera doesn't have a multiple exposure control, take it to the nearest camera shop; they should be able to explain to you how to override the prevention device built into the camera.

Multiple exposures are simply any number of exposures, from two upward, taken on the same frame of film. Each should share a proportion of the exposure so that the total adds up to 100 percent. The easiest way to meter for multiple exposures is to determine first how many exposures you will take on one frame and then increase your ASA setting by that factor. For example, using ASA 100 film, triple exposure: Set ASA dial on or near ASA 300. Each of

the three exposures will thus contribute one third to the total exposure.

Multiple exposures can be frustrating when not planned. Try to envision the final picture and take multiples in which the dark areas of one exposure *do not* coincide with the dark areas of another. Best results occur when the dark areas of one exposure overlap the light areas of another, such as an exposure of a flower over a light sky. You might want to weight the exposures; that is, give a more-than-proportional exposure to the main subject (in the above case, the flower) and less to the sky background. This can be done by adding a half-stop exposure to the flower and subtracting a half-stop from the sky.

Be sure to reset the ASA dial after taking multiple exposures, unless you want to shoot the whole roll this way.

Another variation that produces multiple images on one frame is called *sandwiching.* Using a light box or slide sorter, find two slides

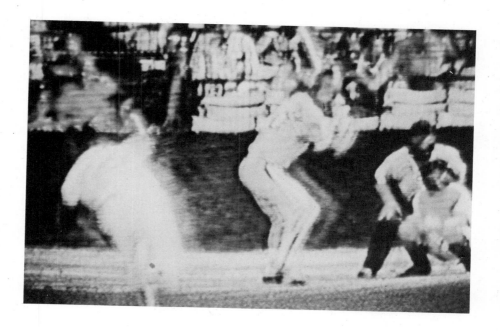

Photograph of a color TV image (converted to black and white). Note contrast buildup. Use low contrast film. Photo by Marc Levey.

that seem to go well together. Lay one on top of the other and view the results. Move them around or try different combinations until you achieve the effect you're looking for. Bind the two slides together and duplicate the sandwich. (For details about duplicating, see books listed in the Bibliography.)

Reflections. Instead of taking pictures of people, still lifes, or scenic views, try shooting a roll of pictures devoted to reflections. Obvious choices for reflection shots are water, shiny cars, wet streets, store windows, mirrors, and any number of glossy surfaces. Patterns or forms created by reflections can range from startling to very subtle. You might want to bracket exposures to explore the color variations of reflections.

Use of Color TV to Create Abstract Images. Wild and weird abstracts are readily available in your living room. Through the use of a color

TV receiver you can literally create an abstract color image of your own composition.

First, find a program, such as a sports event or variety show, that has movement and lots of color. Next, play around with the intensity and hue controls on your set until you arrive at the desired color variation. Then, if the picture is too sharp, use the fine-tuning adjustment to blur the image.

Let's assume you're now satisfied with the picture. How do you capture it on film? You must keep in mind a few facts about TV broadcasting.

1. U.S. TV is transmitted at 525 lines per inch and it takes 1/30 sec. for each complete picture to be transmitted and received. Therefore, a shutter speed of 1/30 sec. or longer must be used in order to record an entire TV picture on film. Anything shorter

How to place a texture screen inside film guide rails. Photo by Marc Levey.

than that will result in a picture's being partially black.
2. Maximum shutter speeds depend upon the type of shutter in the camera used: *1/30 sec.* or slower with *leaf shutters, 1/8 sec.* or slower with *focal-plane shutters* (most commonly employed in SLRs).

Since you'll be using slow shutter speeds and wide lens openings, a fast color slide film such as Ektachrome 200 push-processed to ASA 400 or 800, Ektachrome 400, or an ASA 400 color print film is necessary. Further, color slide film sensitivity is not the same as that of your eyes, so a bit of color correction is in order. We've found that a CC30M or CC30R filter will do the trick. If you choose not to use a CC(color-correction) filter, the results might be on the green side.

Be sure to shoot pictures in a darkened room and let the meter in your camera be your guide, bracketing exposures one stop on either side of the indicated correct exposure. Using an 85–105 mm lens, you can fill the viewfinder frame with a 19-inch TV screen, but for smaller areas some sort of close-up or macro setup is necessary.

The results you get should be quite intriguing. Sharply focused images will appear as a combination of color dots, not unlike newspaper or halftone reproduction. For more abstract images, de-focus the lens slightly.

Panning. One of the great problems in shooting sports or action photography lies in capturing the essence of speed or movement. Use of fast film will allow for hand-holding with a long lens, but most long telephotos have very modest maximum *f*-stops (a typical 300 mm lens has a maximum of *f*/5.6). Small *f*-stops

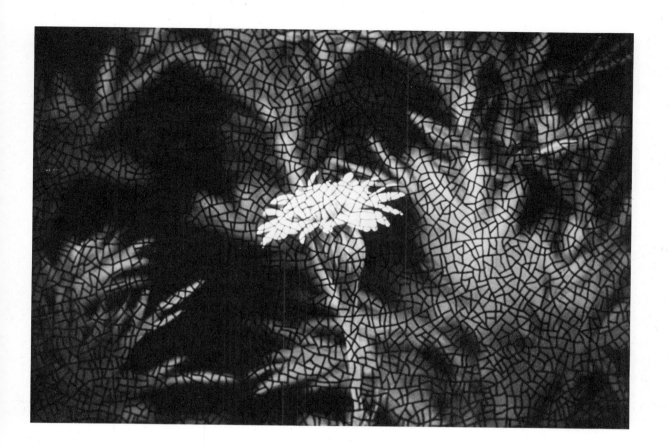

"The Stained-Glass Flower," made with the texture screen in-camera. Photo by Marc Levey.

dictate slow shutter speeds, which in turn can prove to be a pictorial disaster in terms of sharpness. One way of dealing with all these somewhat conflicting photographic dilemmas is through *panning* (review *Things to Keep in Mind* in Chapter I).

Panning is simply the technique of following the action with your camera and taking a photo while the camera is moving along with the subject.

The result of panning, especially when the subject is at or near a right angle to you, is to produce an acceptable picture that would otherwise be impossible to obtain. Many dramatic effects can be achieved if you employ slow shutter speeds (1/4–1/8 sec. or so) and pan. Slow shutter speeds record a relatively sharp subject with a greatly blurred background.

A variation of panning is to pick out a point where the subject will be and then focus on it. The spot you prefocus on should be an easily identifiable one, such as a curve or another spot with a distinguishing landmark. Set your exposure meter, too. Then, *without al-*

The fisheye lens used to render this photograph was built at home at a total cost of $9.75. Photo by Dave Reasinger.

tering the distance you have preset on the focusing ring, pick up the subject (a car, a runner, a galloping horse) and follow it with the camera until the subject is just about to pass the spot you've preselected. A moment or so *before* you anticipate the subject's crossing that point, begin your exposure. In the short amount of time it takes for you to press the shutter release, the subject will have moved to the spot you prefocused on. If you do not begin to make the shot until the subject has reached that spot, the subject will have moved beyond it—and therefore out of the viewfinder—by the time your shutter clicks.

If your camera has a focal-plane shutter, try to make your panning shots in the direction the shutter travels. If you don't, parts of the subject may appear to be distorted.

The two keys to successful panning are to *follow* the action carefully (keeping the subject in the viewfinder at all times) and to *plan* the shot well in advance. Finally, bracket shutter speeds, and then study the results so that you can learn what effect each will produce.

In-Camera Texture-Screen Effects

Texture screens have long been used in the darkroom, but recent years have seen the development of in-camera screens. These commercially available micro screens can be taped to the film guide rails inside your camera so as to impose their pattern along with the image at the moment of exposure.

You can make your own patterns from burlap or another material at home, too, if you're feeling adventurous (see Royal Dossett's book, listed in the bibliography). The only trick is to cut the screen to fit *inside* the guide rails in such a way that it will not affect the film's flatness and, thus, the exposure. Tape the screen in, emulsion side (if any) toward the film, increase your exposure one-half stop, and you've exchanged one more darkroom manipulation for the ease of an in-camera technique.

A Fisheye Lens to Build for Less Than $10

Back to our friends at the Edmund Scientific Company for another adaptation of a commonplace device useful in creative photography.

We all have been tempted at one time or another to spring for a fisheye lens (covering 150–220 degrees), but most of us have been held back by cost and by the sobering knowledge that the lens wouldn't see much use. In fact, most photographers have never enjoyed the delight of viewing the world in this fashion. We think we can solve that want cheaply and with surprisingly good results, to boot.

88

A device called a "snooper" scope, which is used in front doors to view any visitors, can be modified in such a way as to be used as a fisheye lens. This device comes in two parts, one containing the lens elements and the other a threaded tube with a collar. You can get a large, easily adaptable one from Edmund Scientific, or try your local hardware store.

All you need to do is take an old lens cap from your normal or moderate-tele lens, whichever you want to use (this doesn't work too well with already wide-angle lenses) and cut a hole three centimetres (an inch and a quarter) in diameter in the center. Slide the collar of the snooper through the hole and glue or tape it to the back of the lens cap. Be sure it doesn't stick out behind. Screw the lens piece into the collar, fit it on *carefully* over your chosen lens, and look through the viewfinder of your SLR. If you've fitted it to a normal lens (50–58 mm) you'll get about a 160-degree circle. A longer lens will fill virtually an entire 35 mm film frame. The results produced in the accompanying illustration testify to the surprisingly good image quality you can expect.

IV Photographic Prints for Display

Photographers enjoy nothing better than to display their craft, particularly those photographers who take it seriously.

THE PRINT

While slide shows have an obvious appeal to many through the instant critique available from the audience, a large display of pictures (large in size, in quantity, and in the occasion they offer to add commentary) often seems preferable. Nothing is quite so satisfying as to see one's prized photographs well printed and displayed on the wall. This statement is not intended to detract from the creative potential of slide shows, which, when done well, can have an impact uniquely their own. But in this book we are limiting our discussion to the imaginative presentation of prints.

There are two schools of thought relating to prints.

1. The school of "Do it yourself from exposure to framing" insists that photographers must take the picture, develop the film, make the print, mount and frame the picture themselves. In other words, the one person alone has total control over every step in the creative process.
2. The second school says: "Nonsense. Take pictures and let specialists in darkroom work and in print-display assist the photographer in creating the final product."

A lot of photographers come down somewhere in the middle, leaning just a trifle toward the second school of thought. Admittedly, darkroom work can be exciting; but it can also be expensive and very time-consuming. There is a popular fiction that darkroom work done at home is cheaper than commercial work of equally good quality. We can say without fear of contradiction that when you consider the time investment, as well as the material costs of home printing, the comparative cost of printing at home equals or surpasses that of good commercial work. This is especially so in color-print processing. If you are inclined to, go

A color print can be made from either a slide of a negative. Each has specific advantages and disadvantages. Black-and-white conversions of color photos by Marc Levey.

ahead and set up your own darkroom. It can be rewarding. If you decide not to go that route, here are some tips on commercial printing and display. We will concentrate on color prints—the more difficult printing to do well—and their display.

Color Prints

Color prints can be made from either a slide or a negative. Each has specific advantages and disadvantages.

Type R Printing. Prints from slides are generally called Type R prints and are made by projecting a slide directly onto the printing paper. This can be done automatically by machine or by hand in an enlarger.

Be aware that when slides are projected they are transmitted to a screen by a high-intensity light of extreme brilliance. Prints, on the other hand, are viewed by reflected light falling onto the surface; so *don't expect a print made from a slide to be as bright as the projected slide.*

Further, the brightness range of a slide might be as high as 500:1 (comparing the brightest to the darkest area of the picture), but even the best color prints from slides can rarely exceed a 25:1 brightness ratio.

To get some idea of how a slide might ap-

pear as a print, hold your slide at an angle of 45 degrees to a piece of white paper with a light shining onto it from over your shoulder. The image you see on the paper will approximate the brilliance of a well-made print. Any dominating color hue in the slide will become obvious at this point.

Avoid printing overexposed slides; the lack of color dyes in the original inevitably yields a "washed-out" print.

Slides that are greatly underexposed produce contrasty prints with few details in the shadows; shadows simply go black. Projected slides will show shadow detail, whereas prints will not. Recall the differences in brilliance ratios between projected slides and their subsequent prints.

It has been our experience that most machine-made prints made from slides are just awful. Subjects appear fuzzy in these, and the color balance seems arbitrary. However, the new techniques that employ a video scanner and an analyzer can produce very good machine prints, especially if the slide is sharp and well exposed from the outset.

Cibachrome. This Swiss process, which uses azo dyes in place of conventional printing dyes, is now widely available in this country. The virtues of Cibachrome are fourfold. First,

→ 26A ■ → 27 ■

the process uses dyes that are virtually fade-free. Second, the print exhibits a depth and a color brilliance unobtainable in anything but the custom (and terribly expensive) dye-transfer printing process. Third, the printer can work directly from a slide. It's a Type-R-like process. Finally, Cibachrome paper exhibits fine-grain characteristics.

On the minus side, Cibachrome prints are appreciably more expensive than good custom-made conventional prints by about 40 percent; also, the only print-finish currently available is a super-high gloss that some people object to. The high gloss is important, however, as it contributes to the Cibachrome print's great apparent depth and color saturation.

If you are interested in experimenting with the Cibachrome process, kits are available for home darkroom use.

Type C Printing. A print made from a negative, either an original exposed in your camera or a negative made from your slide (an internegative), is known as a *Type C* print. The advantage of printing from a negative is that the printer can manipulate the image in terms of color balance, density, and, to some extent, composition. In addition, specific areas of the picture can be given more exposure (by burning-in) or less (by dodging) to lighten or darken these chosen areas. For many amateurs, a drawback to using negatives is that you cannot preview results the way you can with slides.

Conventional wisdom has dictated that film should be used for its intended purpose, that is, transparency film for slides and negative material for prints. We've found that quality prints can be made from either positive slides or negatives. What really determines the quality of the final print is the quality of the original positive or negative and the craftsmanship of the printer.

The Dye Transfer Process. If highest quality is necessary, consider dye transfer. Although several times more expensive than other methods, this process offers exact control over color balance and contrast at every stage of production.

Dye transfer involves producing color separations from an original negative or transparency on transparent matrix film. These are then soaked individually in their respective subtractive dyes and sandwiched, one by one, onto dye transfer paper, thus producing a color print.

A SAMPLING OF PRINTING LABS

NAME & ADDRESS	11 x 14 INCH PRICE	TYPE	TOTAL AVERAGE TURN-AROUND TIME	SHIPPING	MACHINE OR HAND	CROPPING AND COLOR CORRECTION	COMMENTS
JET COLOR LABS P.O. Box 9777 Seattle, WA 98109	$3.75–4.25	R & C	24–30 Days	$1.75/Order	Machine (Video Scan)	None	Standard cropping. (You'll lose 3 mm [1/8"] from long end of diagonal.)
RETIN-ACHROME P.O. Box 30579 Seattle, WA 98103	$3.75	R only	24–30 Days	$1.75/Order	Machine (Video Scan)	None	Very good quality to 28 × 36 cm (11" × 14"); 41 × 51 cm (16" × 20") can vary (same as above). Both Jet and Retinachrome owned by same parent company. Watch for specials in major photography mags—save money.
UR DARK-ROOM *East* P.O. Box 888H Bridgeport, CT 06604 *West* P.O. Box 80578 San Diego, CA 92138	$5.25 (Neg.) $6.25 (Slide)	Type C (Via inter-negative)	21 Days	$2.00/Order	Hand	• Cropping to your specifications • Limited color cor-rection or darkroom/ lighting	Quality has varied from outstanding to acceptable. Liberal reprint policy.
POSITIVE COLOR Professional Labs P.O. Box 1458 Burbank, CA 91507	$3.50	R only	21 Days or less	None Third Class Mail	Hand	• Cropping to your specifications • Limited color cor-rection or darkroom/ lighting	Very good, consistent qual-ity. Underexposed slides don't print well.
STORMY DAWN Color Labs Box 1017E West En-glewood, NJ 07666	$8.00 (Neg.) $9.50 (Slide)	Type C (Via inter-negative)	14–21 Days	$1.50/Order	Hand	• Cropping to your specifications • Limited color cor-rection or darkroom/ lighting	Included in price is mount-ing on heavy artist's stock.

As most of us cannot afford custom-made dye-transfer prints (typically costing $20–$30 or more for a 20 × 25 cm (8 × 10 in.) print, we look for quality printing at modest cost. The accompanying chart lists several printing labs that are known for their good-to-excellent-quality prints at moderate cost. This list is by no means all-inclusive and does not mean to imply that unlisted labs do not do fine work.

Photo by Bill Coleman.

Summary. Here are some concluding thoughts about commercial prints:

1. If your negative or slide is sharp and well-exposed but the print you receive is not (assuming the size you order is 41 × 51 cm [16 × 20 in.] or less), send it back with a polite but firm letter stating in detail why you find the print unacceptable.

2. Keep in mind that standard cropping will result in the loss of approximately three millimetres (one eighth of an inch) from the long end of 35 mm slides or negatives; so allow for this loss when you are composing and shooting.

3. If you want all of your original printed, specify *full frame*. Prints will be smaller, but the entire slide or negative will appear on the final print. For example: A full-frame print on 20 × 25 cm (8 × 10 in.) paper will have an image area of about 17 × 24 cm (6¾ × 9¾ in.).

4. Before sending a $50 or $75 order out to a commercial lab, try a small order of a few prints first. Then judge the results.

5. Bear in mind that Type C printing (from negatives) emphasizes warm colors while Type R (from slides) emphasizes cool colors. This is inherent in the processes themselves.

6. The standard surface-finish for Type C prints is a semimatte and for Type R a gloss. Many printers will offer different surface-finishes; so be sure to specify which one you want.

If you'll be doing your own printing, you might investigate McDonald Photo Products, Inc., 1211 Gemini Lane, Dallas, TX 75201. This company offers a photo-finishing produce line from coating sprays to mounts. The sprays, which include matte, clear, glossy, and semi-matte, can alter your picture's mood while offering some protection to the print's surface. Two other McDonald products worthy of mention are plaques, which come in a series of shapes and styles suited to a gamut of decors, and a line of print-texturizing materials. Texture effects range from brush strokes to Florentine finishes. The latter, when applied properly (and this takes some practice), adds a dimension similar to the patina of very old oil paintings. These products are fun to experiment with; but, as always, they will do little to enhance a mediocre photograph.

PREPARING THE PRINT FOR DISPLAY

Why do you want to display your print? Here are a few perfectly legitimate reasons:

1. To decorate a room for the sake of esthetics.

2. To decorate a room to please yourself.

3. To demonstrate your craftsmanship.

4. To sell the print, or win a prize.

5. To promote ideas, products, causes.

6. To remember family, pets, etc.

7. To flatter relatives, friends.

Be honest with yourself so that you can maximize the effectiveness of your print. Reread the above list and circle *your* reasons.

Establish the *mood*. What do you want? Reverence? Shock? Serenity? Pride? Order?

Pictures devoid of *impact* should not be openly displayed. What turns you on may not do the same for others. (Display these prints in your more private quarters.) If in doubt, display the print and watch viewers' reactions (no prompting). If reactions are not what you expected, maybe the print does not have the impact you thought it did! But you learned something. Try again with a different print. Soon you will learn to recognize pictures with more universal appeal, more universal impact.

Now, on to the practicalities.

MOUNTING PRINTS

Prints should either be put behind glass in a frame or mounted on stiff material for display. Prints simply pinned or taped to a wall will curl, wrinkle, and distort, and are not very appealing. Mount photographic prints for best results.

Mounted prints store flatter and will not curl with time. Mounted prints handle more

easily and mail safely. Mounted prints look better.

Photographic prints normally do not require the dust or ultraviolet light protection afforded by glass. Most of the following discussions presume you will not be using glass. Many of the following ideas, however, also apply to glass-covered prints.

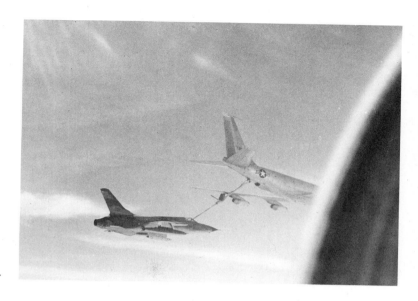

Photo by Marc Levey.

Mounting Terms

BORDER: *The nonimage margin surrounding a picture.* In photography, the margin on a print is a *border*. Any other add-on border is a *mat*. Seldom is the actual print border left visible in displaying prints.

MAT: *An add-on border.* Probably no term is so misused. Webster defines mat as "a border, put around a picture, either as the frame or between the picture and the frame." To "mat" a picture means to add a border.

MOUNT: *Any stiff material to which a print is affixed to keep it flat.* Often the mount is oversized, providing an add-on border, or mat. To mount a print means to affix it to a mount.

BLEED: *To have the image run off the edge.* Bleed prints are borderless. (See also *Full-mounted.*)

FULL-MOUNTED: *The print and the mount are the same size.* The print itself may or may not have borders. Also called "flush-mounted" when *image* and mount are the same size.

MAT-MOUNTED: *The print is smaller than the mount.* The mount provides a mat.

NARROW MAT: *A mat width that is narrow compared to the print's dimensions.* A mat width less than 15 percent of print width is narrow.

WIDE MAT: *A mat width that is wide,* compared to the dimensions of the print. A mat width equal to more than 30 percent of print width is wide.

DOUBLE MAT: *Two add-on borders.* The two mats are usually of unequal widths, a wide and a narrow mat. They may be either superimposed or window-cut.

BACKGROUND MAT: *An add-on background.* The photographic subject is cut out of the print and pasted on the background.

OVERMAT: *A mat placed on top of the print.* The picture shows through a window opening cut in the mat.

RULE BORDER: *A fine line drawn around the print.* The line can be close to the image or close to the frame.

LOW-KEY: *Prints that have very few mid-tones or highlights.* They have many dark shadows.

MID-KEY: *Prints where middle-tones predominate.* Mid-key prints tend to be flat and have few highlights and few really black shadows.

HIGH-KEY: *Prints that are light, with predominately bright highlights.* High-key prints have some mid-tones but no black shadows, only gray.

FULL-RANGE: *Prints encompassing the entire tonal range of the paper.* Most prints fall into this category.

MOUNT THICKNESS
Thickness is given in "points."
(50 point = 1.3 mm = .05 inch)

COMMON NAME	PLY	THICKNESS	PHOTOGRAPHIC USE
Posterboard	2, 4, 6	10–25	Miscellaneous, not for mounting
Light Weight	8,10	30–35	Small prints, to 13 × 18 cm (5 × 7 in.)
Single Weight	14	50–55	General purpose, to 41 × 51 cm (16 × 20 in.)
Double Weight	28	100–110	Frameless, to 41 × 51 cm ((16 × 20 in.)
100% Rag	4	50	Archival mounting
100% Rag	8	100	Archival mounting
⅛″ Masonite	—	125	Large prints, to 61 × 122 cm (2 × 4 ft.)
¼″ Masonite	—	250	Huge prints, to 122 × 244 cm (4 × 8 ft.)
Foamcore	—	250	Huge prints, to 122 × 244 cm (4 × 8 ft.)

Of all these, standardize on Single Weight, 14-ply, for all prints from 13 × 18 cm (5″ × 7″) through 41 × 51 cm (16″ × 20″).

Mounts

The most widely used mount is stiff, multi-ply cardboard. The cardboard is surfaced on both sides with thin paper, which gives it a specific color and texture. Cardboards contain sulfur, acids, and peroxides—all harmful to print emulsions. Buy mounting boards advertised as photo mounts. Your prints will last for decades even though *some* harmful chemicals are present.

A more expensive, 100 percent rag, acid-free mount board decreases chances of a photograph's fading. Use this mount material for your special prints, ones that you want to last longer than your lifetime. Be sure the print itself has been processed for maximum permanence, though, or you're wasting your money on all-rag boards.

Other mount materials include Masonite (for large murals), foam-core (special paper-covered styrofoam board), sheet aluminum, and plywood.

Textures. For full-mounting, smooth mount surfaces are best.

For mat-mounting, slightly pebbled, white, or cream surfaces lend a feeling of quality, especially on portraits. From normal viewing distances, however, the texture is often not apparent; so the use of pebbled surfaces is largely a matter of opinion. Mounting a glossy print on a pebbled mat, for example, is not particularly good practice. All colored mounts, including gray, silver, and black, should be smooth.

Size. Mounts should be of a size and proportion to complement both the print size and shape and the subject matter. Practically speaking, from both display and storage standpoints, it's best to standardize on mount sizes. Adjust *image* size to yield the desired relationships by using standard enlarging papers and cropping judiciously.

Standardize on three basic sizes, 20 × 25 cm (8 × 10 in.), 28 × 36 cm (11 × 14 in.), and 41 × 51 cm (16 × 20 in.). From these make long-or-tall sizes 20 × 36 cm (8 × 14 in.), 20 × 51 cm (8 × 20 in.), and 28 × 51 cm (11 × 20 in.). Or make square sizes 20 × 20 cm (8 × 8 in.), 28 × 28 cm (11 × 11 in.), and 41 × 41 cm (16 × 16 in.). Other combinations, while possible, are less useful and more wasteful of mount and print materials.

To frame long-or-tall and square sizes, you can use the readily available modular frames. Cut the backing board and/or mat from the appropriate standard size.

Mount Sizes

Mount Color. Common mount boards come in white, cream, or ivory, and a variety of grays (brownish, greenish, bluish, neutral). Less common are black, silver, and less common yet, colors.

For full-mounting, the mount color is irrelevant.

For mat-mounting, use white with most high-key subjects, white or cream with blue-toned prints. Warm-tone or brown-toned portraits go well on cream.

Gray mats work nicely with a wide variety of prints, including both portraits and scenics. Be sure the gray is the same color as the grays in your paper. Avoid using greenish or brownish grays, except with very warm blacks. Grays work especially well when a narrow mat is required.

MOUNT COLOR

PRINT	MAT COLOR
Full-range	Gray
High-key	White
Mid-key	Gray, or bleed or full-mount
Low-key	Bleed or full-mount
Blue-toned	White or cream
Red-toned	Cream, or full-mount
Brown-toned	Cream, or full-mount
Color prints	Gray

With color prints, use a medium-tone neutral gray mat. White mats lend a washed-out look to a print; black mats cause the print to recede from the viewer. Bleed-mounting occasionally works well if subject matter is low-key.

Most mount boards have a gray core. Thus, outer edges (when visible) and openings of window-cut mats cut from mount board rather than from regular mat board should be painted to match the mat color. Felt-tipped markers work nicely.

Consider silver where you might use a medium gray but wish the effect to be brighter. Use medium-width mats. Silver can distract if not properly used.

Wide black mats convey a feeling of depth. Be sure subject matter is appropriate. Black mats are tricky to use properly.

Low-key prints and prints toned warm colors (orange, red, brown) usually look best flush- or bleed-mounted.

In general, don't use colored mats. Now that you know the rule, find appropriate ways to break it. Most of the time the results will be terrible. But occasionally, a very striking mat-and-picture color combination results. It's best to experiment with colored background mats or overmats instead of colored mounts. It's cheaper!

Techniques

Dry Mounting. Dry-mounting tissue is thin tissue paper impregnated with a meltable adhesive. The sandwich of print-tissue-mount sticks together upon the application of heat and pressure. On cooling, the sandwich is flat and stiff. Dry mounting is the best, and least messy, method of mounting. Even wavy prints lie neat and flat.

Select the proper type of dry-mounting tissue. Thermosetting tissue melts and sets at about 93–135 C (200–275 F) and is permanent. Thermoplastic tissue melts at lower temperatures and can be reheated to remove or reposition the print.

Select a thermosetting tissue for permanent black-and-white work. Select a thermoplastic tissue for color or temporary work, or for resin-coated papers.

Presses for dry mounting have a large heated platen. They are expensive. Tacking irons, resembling large soldering irons, lightly tack the dry-mounting tissue in place. They're an additional cost. Ordinary flatirons do nicely for both jobs. Steam irons work, too, but be sure the *steam is off.*

For a black-and-white print, set the flatiron to about 104 C (220 F). That's around "wool." Since this is just above the boiling point for water, a wet finger touched to the iron

1 TACK 2 TRIM 3 TACK 4 IRON AND PRESS

Dry Mounting

should produce a faint "sizzle."

Place several layers of newspaper (15–20 pages) on the table and iron them flat.

Get a piece of clean paper larger than the print. Thin posterboard is good. Typing paper will work, if large enough. Brown wrapping paper also works. Select a mounting tissue the same size as the untrimmed print. Place the untrimmed print face down on the newspaper. In humid weather, lightly iron the print to drive out moisture. Place the tissue on the print back and lightly tack the center, using the iron's tip. On larger prints, also tack near each edge. Now trim the print and tissue to finished size.

Iron the mount, from the back, to drive out moisture. Turn the mount face up and position the print (and tissue) in place. Carefully lift a corner of the print and tack the tissue to the mount. Repeat on the other corners. Check to be sure the print is square and properly positioned.

Place the clean paper on top of the print. Starting from the center, use a piece of 1 × 4-inch lumber laid across the middle to press and hold the assembly. Run the iron over a

strip adjacent to the board. Quickly slide the board over the ironed area. Press hard for a few seconds. Meanwhile, iron the next strip. Repeat. The final pass should catch just the last critical inch or so of the print edge. Press and hold for a few seconds. Turn the print around and repeat on the other half. Finish by giving the top and bottom edges an extra pass with the iron. Press and hold for a few seconds. The whole procedure takes less than a minute.

Place boards or special weights or books on the assembly to keep everything flat while it cools. Wait a few minutes, then test the sandwich by flexing, corner-to-corner. If the print pops loose, either the iron wasn't hot enough or you worked too fast. Re-iron, making proper adjustments in your procedure.

On larger prints, 28 × 36 cm (11 × 14 in.) and up, you may wish to work on one-fourth of the print at a time.

To remove, cover the mounted print with clean paper. Heat one corner and carefully lift it. Progress along one edge, then across the print, applying the iron just ahead of the separation. Be careful not to wrinkle or crease the print. Tissue may remain on the print or on the

MOUNTING METHODS

METHOD	BOND	FADE-LIFE	USE
Dry Mounting	Excellent	Decades	Permanent, flat mounting
Adhesives	Very Good	Years	Quick mounting
Rubber Cement	Good	Months	Paste-ups
Wet Mounting	Good	Years	Huge prints
Tapes	Fair	Months	Temporary mounting

mount, depending on several factors. Remove the tissue by covering it with scrap paper (newspaper is OK) and work as above, peeling tissue away. Use lacquer thinner, benzine, or film cleaner to remove any remaining traces of adhesive.

Mounting color prints and those on resin-coated (RC) papers is trickier, since the emulsion in color prints and resin coatings melt easily. Use as low a temperature as possible. If the cover paper sticks to the print, use heat to unstick.

Experiment on reject photos before attempting to mount a prize print.

Adhesives. Liquid adhesives for photo mounting are generally painted on or sprayed on. Select only adhesives specifically formulated for photo mounting. Most other adhesives contain chemicals very harmful to print emulsions. Even so-called "photo" adhesives have some harmful chemicals.

Most photo adhesives are pressure-sensitive. That is, they are allowed to dry to a tacky state before the print is pressed in place. Most, however, can also be applied wet, with a resultant bond that is not as strong.

For best bonding, coat both print and mount with the adhesive. Spray or brush on a uniform coat. Be particularly careful near the edges, allowing them to dry until the adhesive forms a string when touched but does not stick to your finger. The adhesive now has the right tackiness.

Very carefully align the edge of the print with the edge of the mount. Progressively lay and press sections of the print in place. Use the heel of your fist, or a rag, or a roller. Work carefully. Once laid down, the print cannot be removed. Any bubbles and wrinkles are permanent. The bond is very strong and permanent.

For mat-mounting, only the print can be coated with adhesive. As soon as the adhesive begins to be tacky but is still wet, position one edge of the print on the mount and progressively press in place as illustrated. Depending on the adhesive, and the thickness of application, the print may or may not be removed for repositioning.

A very light adhesive coating, dried beyond the good tack stage, generally means the print can be easily removed. Use this technique only for temporary mounting, though.

You can apply the print while the adhesive is wet. This allows you to slide the print to final position. This technique is messy, since adhesive squeezes out upon pressing, and the bond is not as strong. Avoid this method if possible.

Pressure mounts, precoated with a sticky

ALIGN EDGES

COAT MOUNT AND PRINT

LAY DOWN

Adhesive Mounting

adhesive, work well for quick mounting. They're expensive, and only good for full-mounting. The bond is not as good as when both sides are sprayed. The print is removable if you're careful.

Use film cleaner, denatured alcohol, oily nail-polish remover, or acetone to remove excess adhesive. Read the directions on the adhesive bottle or can.

Of all the adhesive approaches, only the double-coat method yields a bond approaching that of dry-mount tissue. Consider adhesives for quick mounting or if you've tried dry mounting as described and *still* have problems. Incidentally, your print *must be flat*. Wavy edges or warped prints do not flatten out with adhesive mounting as they usually do with dry mounting.

Don't use ordinary rubber cement. This adhesive is acceptable for short-term photo mounting (printers use it for paste-ups), but prints will begin to yellow in just a few months. Mild adhesives, such as library paste, white latex glues (Elmer's, Sobo, Magic-Mend), flour-and-water paste, etc., are better; however, they are all somewhat hygroscopic and will absorb moisture. Eventually the print may come loose, or turn yellow.

Tapes. Most double-sided tapes do not hold prints very flat. Most tapes have chemicals that will discolor print emulsions over several years. Use tapes only for temporary mounting.

Run the tape along all four edges of the print back. Do not stretch the tape; let it lie naturally. Place pieces of tape spaced five centimetres (two inches) apart over the entire back of the print. Lay down one edge on the mount and progressively smooth down the print.

Wet Mounting. Large prints, especially ones more than 41 × 51 cm (16 × 20 in.) in size, are tricky to mount with dry-mounting or adhesive-mounting techniques. Bubble- and wrinkle-free application is tough to achieve. If the print is mounted while still wet, however, bubbles may be pressed out, and the print shrinks to a smooth fit as it dries. The mount, of course, must be able to withstand soaking.

The most common wet mount is quarter-inch tempered Masonite. Use water-soluble glues, such as paperhanger's paste or printer's padding compound. Size the Masonite by painting both sides with thinned adhesive. Allow to dry. Coat one side with adhesive and apply the wet print. Press out all the bubbles and excess

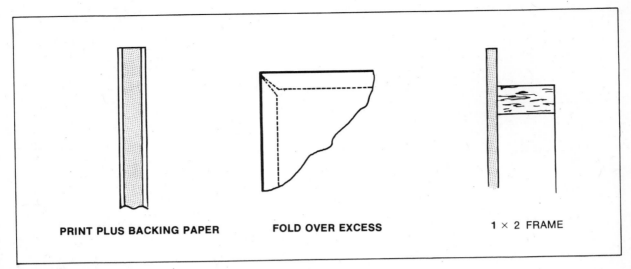

PRINT PLUS BACKING PAPER **FOLD OVER EXCESS** **1 × 2 FRAME**

Wet Mounting

adhesive, using a squeegee or damp sponge. Similarly, mount a piece of brown wrapping paper or a reject print on the back side. This provides a balancing force to the shrinking print. Weight or clamp with boards. Make sure to clamp the edges.

If the print is at least an inch over-size on all edges, cut and fold over the excess for bleed-mounting. Tuck the edges under the backing paper. Alternatively, trim all excess edges after the assembly is fully dry, sand print and board edges smooth, and paint the edges white or black.

You may wish to use a 1 × 2-inch frame on the back, both to hang the print and to keep the board flat. Nail the frame to the board before mounting the print. Countersink the nails, fill the nail holes, and sand the surface flush. No backing paper will be necessary.

Alternatively, apply the frame with contact cement after the print and the paper backing have been mounted and have dried.

Remove all traces of glue from the print's face while wet. After drying, the glue is impossible to remove.

Make murals by splicing several prints. Be sure the prints are similarly exposed so that they match in tone. Be sure all images overlap. Carefully tear one mating edge. Lay this over the other matching edge for a random, feathered overlap splice. Or cut one edge only, following some vertical object in the picture, and sand the edge from the back to produce a very thin, tapering edge. In either case, use a strong pressure-sensitive adhesive for joining the prints. Wet-mount the entire assembly, after the prints have been joined firmly together.

On large murals, shrinkage may pull the lap-joint apart. To be safe, wet-mount one print at a time. Allow the print to dry (and shrink) and then wet-mount the next. Note the amount of shrinkage on the first print; allow for this on successive prints. Or, carefully clamp across the overlap joint to prevent movement at the juncture.

Butt joints don't work. On drying, the joint opens up because of print shrinkage. You could make butt joints, however, and use thin moulding strips to cover the gaps. A sort of window effect results.

104

FEATHERED OVERLAP SPLICE

Splicing

PRESENTING THE IMAGE

Full-Mounting for Framing. Check to be sure any print borders will be covered by the frame. Most frames have at least a 6 mm (¼ in.) rabbett or a groove and will cover the 4.6 mm (³/₁₆ in.) borders left by easel arms. Be sure the subject matter lends itself to a no-mat approach. Corner flashing (darkening corners and edges during printing) helps both portraits and scenics. Low-key prints work very nicely full-framed.

Full-mount prints with wide, photographically made borders, too. Remember, the frame will cover about 6 mm (¼ in.) of the borders.

Mat-Mounting for Framing. Trim the print so it will be smaller than the mount board. The mount board then provides add-on mat borders.

The term "matting your print" is used loosely by photographers. In this book, we use the term "mat-mounting" to mean just that—mounting, but on an oversized mount so as to create a mat.

There are other methods of matting prints,

which will be discussed farther on.

Mat Contrast and Size

Let's see what effect white, gray, and black wide mats have on high-key, mid-key, and low-key prints. Remember, high-key subjects are mostly white, mid-key mostly gray, and low-key mostly black.

In general, small prints require a wider mat for their size than do larger prints. The mat should not be so large as to diminish the subject matter nor so small as to look merely like a simple frame.

The top and sides should be of equal width, the bottom slightly larger, on vertical prints. On horizontal prints, the bottom and sides should be equal, the top slightly smaller.

If hung frameless, use a wide white mat on high-key prints, narrow gray mat on full-range prints, no mat (bleed or flush) on low-key.

Work out some standard mat widths to use with standard papers and standard mounts. (See Matting Guides.)

Photo by Marc Levey

FULL MOUNTED

Photo by Bill Coleman

MAT MOUNTED

Photo by L. P. Greenhill, F.R.P.S

FULL MOUNTED

Photo by Bill Coleman

MAT MOUNTED

Mounting

Whatever your reason for displaying a particular print, you will wnat to mount it for the sake of aesthetic appeal and lasting protection. Deciding just how to mount it is comparable to selecting the setting for a diamond: Every facet of the piece must be shown to best advantage. Full-mounting, where the print and the mount are the same size, works best for some subject matter. If an add-on border will provide the finishing touch to your picture, however, settle on mat-mounting (with the print smaller than the mount).

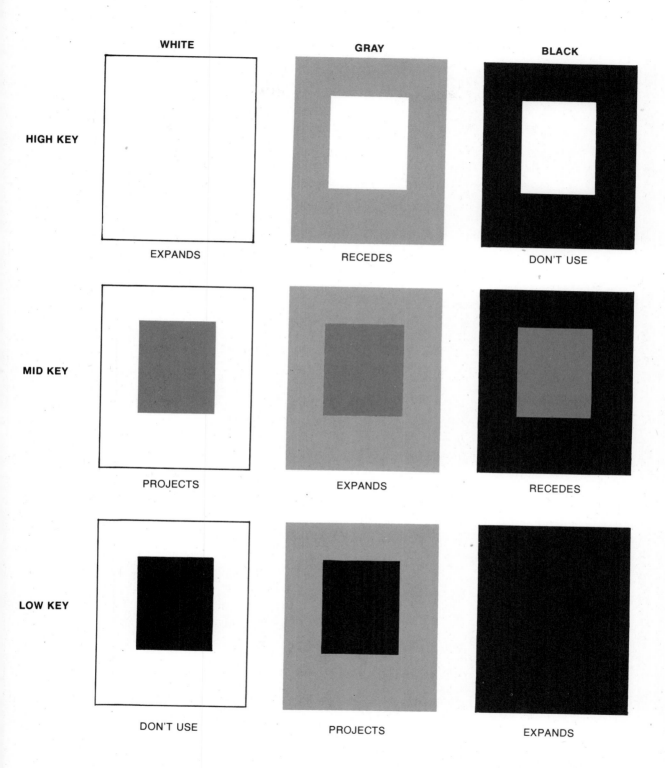

	WHITE	GRAY	BLACK
HIGH KEY	EXPANDS	RECEDES	DON'T USE
MID KEY	PROJECTS	EXPANDS	RECEDES
LOW KEY	DON'T USE	PROJECTS	EXPANDS

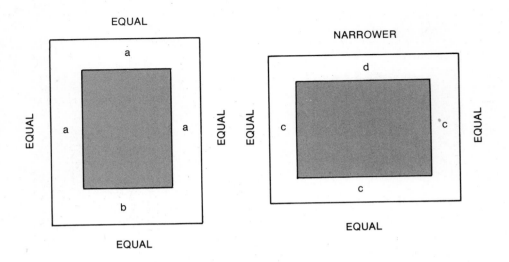

SMALL PRINT—WIDER MAT

LARGE PRINT—NARROWER MAT

The airy pose of th ballerina in the background suggests a flight into space that only a bleed mount could do justice to. Photo by Bill Coleman.

A narrow mat serves to complete this landscape without cutting down on the expansiveness that its horizontal format projects. Note the "globe" effect produced by darkening the edges of the image (a technique known as "corner flashing"). Photo by Marc Levey.

The crispness of this portrait is heightened by a wide mat that draws the viewer's attention to the heart of the scene because it amplifies the spirit radiating from the woman's face. Photo by Bill Coleman.

NO MAT

NARROW MAT

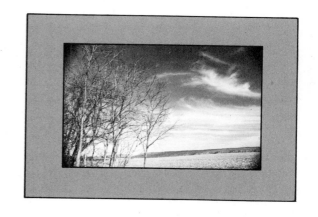

WIDE MAT

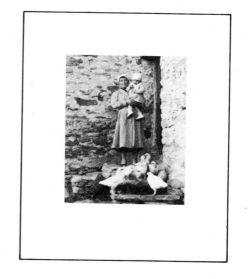

BACKGROUND MAT

Product photos stand out impressively against a background mat, as there is no clutter to detract from the item in question. Simply cut out the central figure from your print, then paste it directly onto the mount. Nikon FM. Photo courtesy of EPOI, Inc.

Bleed or Flush Mount. If the print is to be hung frameless, and is a bleed print mounted flush (no border or mat), paint the mount's edge to match the print. Use ink or felt-tipped markers.

In general, high-key and full-range pictures do not look good bleed-mounted; low-key pictures look very nice this way, as do mid-key subjects with dark backgrounds.

Remember, if a flush-mounted print is subsequently framed, the frame will cover at least 6 mm (¼ in.) of the image all around.

Narrow Mat. A narrow mat is really an extension of the frame, or sometimes the only frame, rather than a separate bordering element. Treat it as such.

Use narrow gray mats on large, expansive, horizontal prints, especially if framed in narrow frames. Avoid white or black narrow mats, except for special effects.

Mid-key prints that must be hung frameless often look best with a narrow gray border. In this case, the narrow mat becomes the frame.

Wide Mat. Most of your prints, especially portraits, will probably look best with wide mats. The mat will enlarge, project, emphasize, and/or add depth to the subject matter. Wide mats are used alone or in combination with a ruled border or a double mat.

Borders

Background Mat. Cut out the central figure or object from the print. Paste this directly onto the mount or onto a colored piece of construction paper. Mount and frame. Hang in a grouping for best effect.

This idea works very nicely with family head-only portraits, with product photos, or with pictures of a collection (vases, guns, autos, etc.). Background mats work best with crisp, contrasty prints.

Bottom Border. For a clean, technical display, mount the picture flush on three sides and leave a wide border at the bottom only. Be sure the print has a clean background, all the way to the edges. Bottom-border prints usually look best unframed.

Use white bottom-border mats to display scientific apparatus or scientific research photos.

Ruled Borders. A border rule is a narrow

BOTTOM MAT

The intricacies of sceintific apparatus call for a clean, professional display in photographs. A wide border at the bottom, with the otehr three sides flush-mounted, works particularly well when the background of the picture is equally austere. Photo by Joseph Bodkin.

line placed either close to the print or close to the frame.

Often the gray mat on mid-key and full-range prints is of a tonal value similar to the print's. The mat tends to look like an extension of the print background. A rule in the border close to the print separates the two nicely. The rule near the print contains and draws attention to the subject.

Use the print-rule on most portraits (people and animals), still lifes, etc. Do *not* use print rules on landscapes. Here you want to expand and give presence to, rather than confine, the subject matter.

Rules around prints on white mats provide a formalizing effect. Use this technique on pictures of formal occasions, copies of documents or awards, military portraits, etc., anywhere you wish to create a feeling of formality or prestige. If the print has a predominately dark or black background bleeding off the edge, a rule should not be used. The contrast between the print and the mat is sufficient.

A rule close to the frame serves to decorate and embellish the frame. Frame rules work particularly well with narrow mats. Such things as landscapes and narrow-matted portraits are likely candidates. The rule enhances the frame without unduly confining the sub-

ject. On larger frames (28×36 cm, 11×14 in. up), try double frame rules. In any case, be sure there is a generous mat area left between the rule and the print.

Do not mix the two techniques—print rules and frame rules.

Of all the ways to make rules—black pencil, ruling pen, photo masks, etc.—the simplest and most versatile is thin black chart tape. The tape can be laid down straight and clean, may be readjusted, or may be removed entirely if the effect is unsatisfactory. Look for narrow tapes at graphic-art supply houses. Buy the .8 mm (1/32 in.) tape.

Place print rules about 3 mm (1/8 in.) away from print edges. *Slightly* stretch the tape, and lightly press it in place. Tape stretched too tightly will pull short after a while. Trim the corners square with a razor knife.

Position frame rules inside frame edges at a distance equal to three-quarters of the width of the frame, or less. Never allow the spacing to be greater than the frame's width.

Rule Borders

PRINT RULE **FRAME RULE**

Mat Variations

Double Mat. Add a second, narrow mat, and the print receives special emphasis. The effect is similar to print-ruled borders, but less formal. Double mats work progressively *less* well as subject matter increases in complexity.

Use a double mat with small prints on large mounts, both to emphasize the small print and to de-emphasize the extraordinarily wide mat.

Try construction paper, artists' paper, etc., for double mats, using mat-mounting techniques. Cut it larger all around than the print, but no more than one-fourth the width of the main mount width. Dry-mount or adhesive-mount the second mat to the mount board. Then mount the print. Use black or very dark gray paper. Avoid colors, unless the color is repeated in the print, the frame, or both.

Although triple-mats (and more) can be made with stepped, concentric mats, rare is the print that will look good with a triple mount. Experiment!

Multiprint. Trim several similar small black-and-white or color prints. Mount on a large gray mount. This is a neat technique for family trees, organizational charts, process flow, bar charts, collections, etc.

Overmats. An overmat is a mat placed on *top* of the print. If the mount board color, texture, or pattern is not suitable as a mat, use an overmat cut from construction paper, wallpaper, gift wrapping, or matboard. Overmats provide a wide range of colors, patterns, and shapes.

Cut opening shapes to suit the subject. Try a heart, keyhole, cross, binoculars.

Cut the overmat's outside dimensions to match the mount board. Glue or tape (double-sided) the overmat to the mounted print being aware this will eventually stain the print. For the most permanent assembly, use the dry-mount method, tacking the mounting tissue to the overmat before cutting the outside edges and opening. If the print will be framed under glass, the overmat need not be attached, however.

For deckle-edged (fuzzy) overmat openings, cut the opening corner-to-corner, fold along the edges, and tear away the excess.

Mount Overmat. Overmats need not be made of thin paper. Another approach is to cut out a window in a matboard and place the picture behind the opening. A slight depth results, an effect favored by many. The mat must be cut

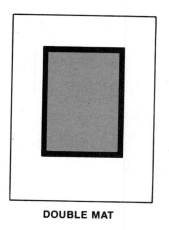

DOUBLE MAT

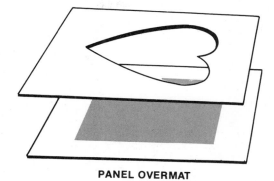

PANEL OVERMAT

Mat Variations

MULTIPRINT

DECKLE-EDGED

very cleanly and the window edges colored—if mounting board is used—or the effect is one of sloppiness. (See Cutting and Trimming.)

Mount the print as usual on a mount board. Trim the mount and print to be 6 mm (¼ in.) larger on all edges than the overmat window. Tape the mounted print in place behind the opening.

Covered Overmat. Overmats made from mount board material provide a solid form for

covering. Use any of the following coverings: foils, linen, burlap, textured paper, gift wrapping, wallpaper, newsprint, velvet, printed fabrics.

Cut the material slightly larger than the window-cut overmat. Glue or dry-mount the fabric to the mat.

Cut an opening in the fabric 25 cm (1 in.) smaller on all edges than the window opening. Cut the inside corners at 45 degrees, beginning 1.6 mm (¹⁄₁₆ in.) from the corner of the opening.

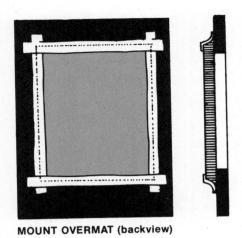

MOUNT OVERMAT (backview)

FRENCH MAT (frontview)

Mat Variations

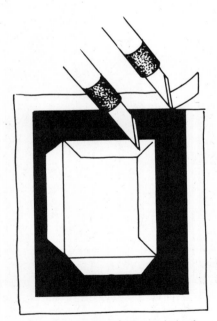

COVERED OVERMAT (backview)

Fold the material inside the opening and glue. The slight rounding of the inside corners is desirable. Fold back all excess edge material and glue. (If it is to be framed, merely trim all the outside edges flush.) Tape the mounted print in place.

Covered overmats go especially well with photo-oil-colored portraits and large landscapes.

Fancy Overmat. Decorative rulings, border designs, etc., added to a simple mat can enhance very simple pen-and-ink line drawings. However, such "French mats" are generally not suitable for photographic prints. Exceptions might be "old-fashioned" portraits or photo copies of line drawings.

Depth Mounting. Simple mount overmats add a bit of *actual* depth to the print display. The accompanying illustrations show more ways to add depth, using mount board. Use contrasting tones to increase the effect by adding *visual* depth.

Try some combinations of your own.

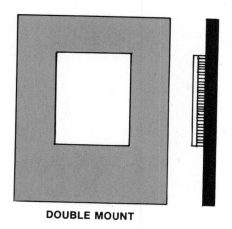

DOUBLE MOUNT

DOUBLE MOUNT MAT

Depth Mounting

Mat Basics. Now we can lay down some basics, to be used most of the time but to be broken for special effects.

**DOUBLE MOUNT
AND MOUNT OVERMAT**

MAT BASICS

IMAGE	MAT
High-key	• wide white mat
	• wide gray mat to enlarge
	• narrow gray to give presence
	• narrow gray mat if hung frameless
Mid-key and Full-range	• double mat to emphasize small prints
	• rule border to separate, focus attention
	• background mat to simplify
	• overmat for effects
Low-key	• bleed or flush-mount
Color print	• gray mat
Blue-toned	• white or cream mat
Brown-toned	• cream mat or flush-mount
Photo-oil-colored	• covered overmat

VERTICAL THEME Photo by James Forkner

Dominant Form

The dominant *form* of the subject matter in a photograph will influence your considerations regarding mount proportion, mat placement, and mat size. In these instances, the rules of mat proportions work in reverse; thus, a wide mat will be your choice for emphasizing space, while a narrow mat will magnify the size of the image.

HORIZONTAL THEME Celestron 1250 mm photograph

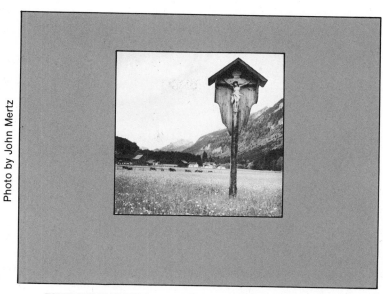

Photo by John Mertz

EMPHASIZE VERTICAL SUBJECT IN HORIZONTAL THEME

EMPHASIZE HORIZONTAL SUBJECT IN VERTICAL THEME

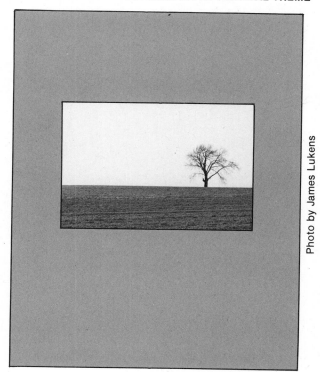

Photo by James Lukens

Proportions

Dominant Form. Always choose mount proportion—and mat placement and size—to complement the dominant form of the subject matter, as shown in the accompanying examples.

This is the time to violate the rules of mat proportions. A wide mat *emphasizes* and continues *space;* conversely, a wide mat *diminishes* the size of *images*. Disproportionate mat width forces attention to the center, yet preserves either a vertical or a horizontal theme.

Dominant Mood. Mounting techniques must at best enhance, and at worst preserve, the mood of the subject matter. Note that vertical and horizontal themes help convey opposing moods. For further, subtle enhancement, select the proper mat technique. Then select the mat color.

117

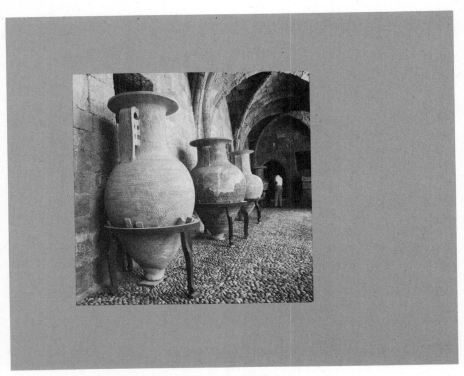

EMPHASIZE SIZE Photo by Bill Coleman

FORCE ATTENTION Photo by Bill Coleman

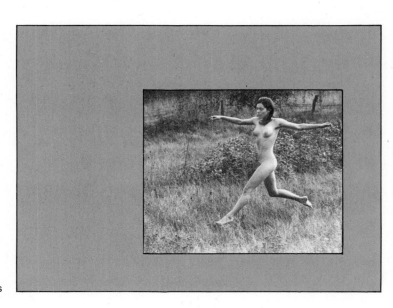

FORCE ATTENTION Photo by James Lukens

STATIC, TENSE Photo by Marc Levey

DOMINANT MOOD

VERTICAL	HORIZONTAL
Static	Dynamic
Tense	Serene
Remote	Intimate
Deep	Spacious
Formal	Informal
Ambitious	Lazy

A formal portrait and a serene seascape convey vastly different *moods,* and the mount you select for each should reflect this. Even the color of the mat to be used is an integral part of display effectiveness. As the following photographs demonstrate, if you give your mount selection the same careful consideration you invested in the making of the print, your reward will be handsome.

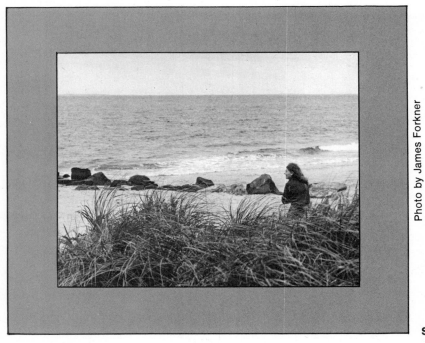

Photo by James Forkner

SERENE, SPACIOUS

120

UNCLUTTERED (background mat)

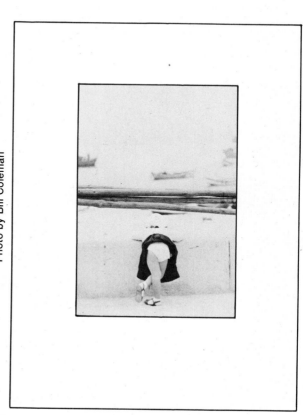

CLEAN (high key, white mat)

INFORMAL (gray mat) Photo by Marc Levey

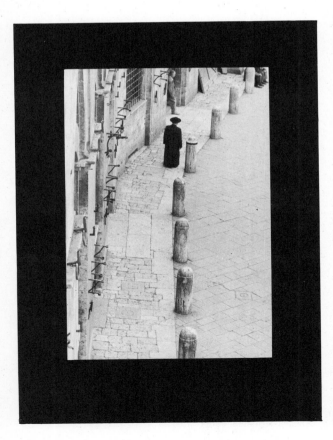

DEPTH (black mat) Photo by Marc Levey

Photo by Marc Levey

FORMAL (rule border) (print rule)

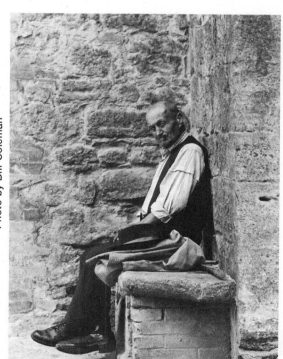

Photo by Bill Coleman

MOODY (flush without border)

Mat Color

WHITE PROJECTS

GRAY EXPANDS

Photos by Joseph Bodkin

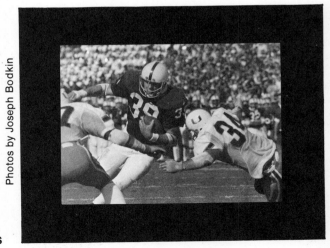

BLACK RECEDES

124

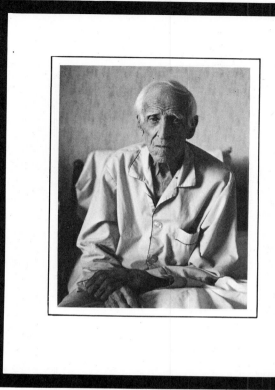

FORMAL PORTRAIT (note print rule border)

Photo by Denis Aumiller

SOFT, HIGH KEY (note wide, white mat)

Photo by Marc Levey

125

Photo by Marc Levey

LITTLE-PEOPLE APPEAL (note wide top mat)

ENTHUSIASM (note square treatment to focus attention)

Photo by Bill Coleman

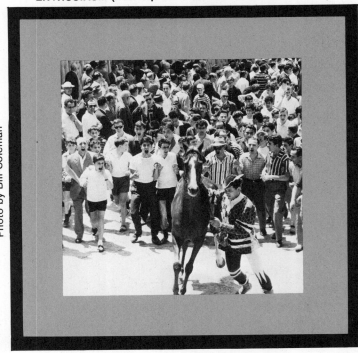

Photo by James Lukens

INTIMATE PORTRAIT (note horizontal treatment)

VERTICAL SUBJECT, HORIZONTAL THEME (note wider side mat)

Photo by Marc Levey

FACE UP **FACE DOWN**

Cutting and Trimming

Cutting and Trimming

Equipment and Method. Cutting mounts to size (outside cut) is fairly easy. Use a sharp razor-edged knife for cutting smooth, rag-free edges. Better yet, purchase mounts precut to size. (See Mount Size.)

Inside cuts, for making window overmats, require a slim, sharp knife or a one-sided razor. Mark all corners with a pencil dot or a push-pin prick. Place the mount on a scrap mount board. Using a steel straightedge, cut an edge in one clean, smooth stroke. Stop just short of the corner. Insert the knife in the corner and cut *towards* the just-cut edge. Repeat on all four sides. Punch out waste.

It's easiest to cut from the front surface. Place the straightedge on the mat side of the line, not the opening. If you slip, you'll only cut the waste material in the opening.

Professional-looking bevel-cut overmats are difficult to cut without bevel guides. If you have a steady hand, try it. Cut from the *back* side of the mount, to ensure straight edges adjacent to the print.

Some sort of T-square should be used in laying out the corners of the opening. Or measure equal distances in from an edge. Or make some guides from mounting material. Use a piece of mount board to quick-check the final

CUTTING AND TRIMMING

TOOL	OUTSIDE CUTS	INSIDE CUTS
Scissors	Oval prints	No
Guillotine trimmer board	Prints, overmats	No
Knife trimmer board	Mounts, prints, overmats	No
Razor knife	Mounts, prints, overmats	Overmats

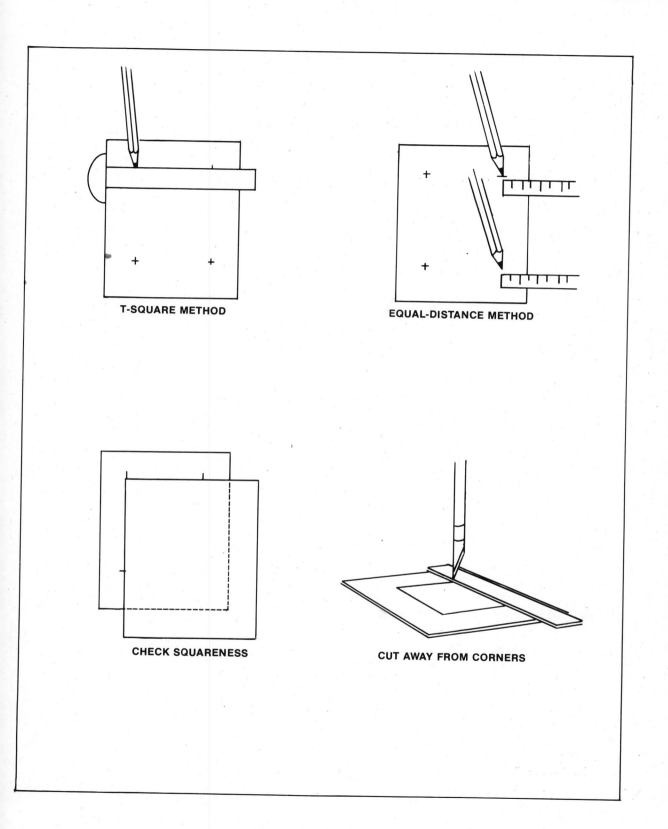

T-SQUARE METHOD

EQUAL-DISTANCE METHOD

CHECK SQUARENESS

CUT AWAY FROM CORNERS

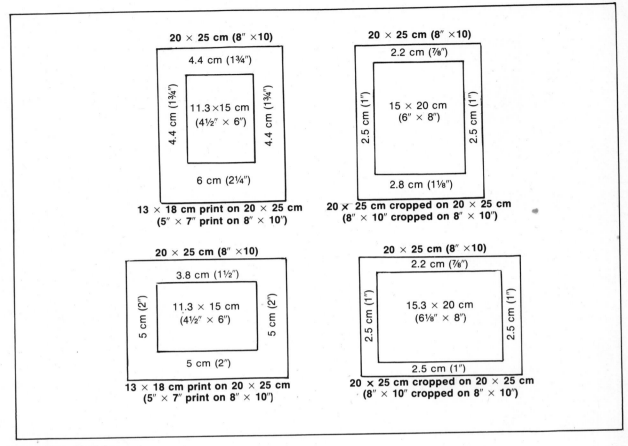

Matting Guides

layout for squareness.

Buy standard-sized mounts, if possible. This will save you a lot of trouble. Avoid further cutting by mounting prints (instead of constructing window-cut overmats). This requires only a quick trimming of the print, which is super-easy if you use a transparent plastic guide, razor knife, and straightedge.

Matting Guides. Make the following standard matting guides from standard-sized mount board. Cut the openings per the dimensions shown. Use them to:

1. Lay over print to crop and mark print corners for cutting.
2. Lay over mount to mark corners for mounting.

Also use them as templates for marking overmats and under the enlarger as cropping guides.

Better yet, buy guides printed on clear plastic. These guides cover all the sizes here, plus many more. They're quite inexpensive and take all the hard work out of matting prints.

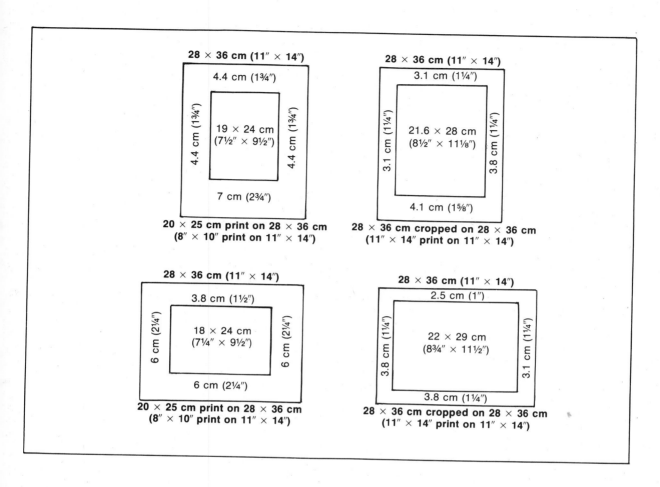

28 × 36 cm (11″ × 14″)

4.4 cm (1¾″)

4.4 cm (1¾″) 19 × 24 cm (7½″ × 9½″) 4.4 cm (1¾″)

7 cm (2¾″)

20 × 25 cm print on 28 × 36 cm
(8″ × 10″ print on 11″ × 14″)

28 × 36 cm (11″ × 14″)

3.1 cm (1¼″)

3.1 cm (1¼″) 21.6 × 28 cm (8½″ × 11⅛″) 3.8 cm (1¼″)

4.1 cm (1⅝″)

28 × 36 cm cropped on 28 × 36 cm
(11″ × 14″ print on 11″ × 14″)

28 × 36 cm (11″ × 14″)

3.8 cm (1½″)

6 cm (2¼″) 18 × 24 cm (7¼″ × 9½″) 6 cm (2¼″)

6 cm (2¼″)

20 × 25 cm print on 28 × 36 cm
(8″ × 10″ print on 11″ × 14″)

28 × 36 cm (11″ × 14″)

2.5 cm (1″)

3.8 cm (1¼″) 22 × 29 cm (8¾″ × 11½″) 3.1 cm (1¼″)

3.8 cm (1¼″)

28 × 36 cm cropped on 28 × 36 cm
(11″ × 14″ print on 11″ × 14″)

Matting guides can be constructed at home or purchased at a small cost. They are indispensable for cropping, cutting, marking, and making overmats for prints. Photo courtesy of Falcon Safety Products.

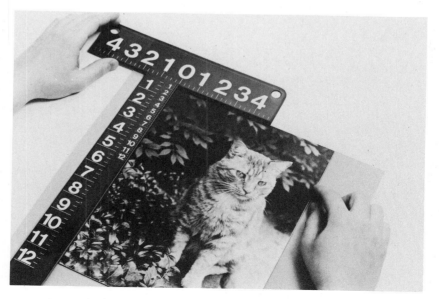

131

TITLE (burn in with small flashlight)

AFTERWARDS

Exhibitions

Regardless of the print size, most salons prefer 41 × 51 cm (16 × 20 in.) mounts. Mounted prints this size probably are more saleable than smaller sizes, too, should you choose to sell. Also, they are easier to frame than some nonstandard large mounts.

Avoid double mats. If you wish, use a thin rule border, instead. Keep the title and signature, if used, small.

Frame exhibition prints with simple narrow black frames. Use silver accents (lip) if you wish; use all-silver only if the subject matter is appropriate.

If the print is to be hung frameless, tape or glue 19 mm (¾ in.) wood blocks to the back of the mount.

Remember, it's the print that's on display. The mount or frame should not distract. Aim for the most impact from a viewing distance of about two metres (six feet). But be sure the picture will survive closer scrutiny.

Low-key prints present a special problem. A 41 × 51 cm (16 × 20 in.) bleed mount is effective. Flash the print to produce black to the edges. Or try a black mat with a 28 × 36 cm (11 × 14 in.) or 36 × 43 cm (14 × 17 in.) print.

Identification

Do not write on prints, front or back, with ordinary pencils or pens—unless you *want* to dent or emboss the emulsion. And felt-tipped markers may show through from the back or smear on the front.

Rubber stamps, especially the small self-inking type, are best for marking the back of your prints or mounts. A simple stamp with your name works fine.

Signatures on the front of the mount should be very small, at the lower right, near the print. Use a *black* pencil (most pencils write gray) or black ink.

Titles look best if they are set in type rather than hand-lettered. Typing on mounts is

TITLE (add during exposure of print)

impossible. The smartest solution is to obtain some transfer lettering sheets used by graphic-arts people.

Or add titles photographically, either black on the white border or in a clear area in the picture, or white against a dark area of the print. Add black titles via a photo mask. Add white titles via transfer lettering on a small, flat, clear acetate sheet, laid on top of the enlarging paper. A narrow border frames the title and eliminates edge-diffraction effects of the acetate sheet.

Mailing

Mounted prints are easy to mail. You will find that 20 × 25 cm (8 × 10-inch) mounts fit standard 23 × 31 cm (9 × 12 in.) kraft envelopes; 28 × 36 cm (11 × 14 in.) and 41 × 51 cm (16 × 20 in.) mounts require larger envelopes. Check your local stationery or art-supply store, or write to one of the suppliers of photo mailers. Use a second mount board to protect the face of the mounted print.

Save your empty boxes from enlarging paper or mount board to use for mailing several mounted prints. Use fiberboard mailing/carrying cases when a large number of prints must be shipped or transported, as to exhibitions. Or carefully pack the pictures in corrugated boxes.

Storage

The enemies of photographic prints are chemicals, light, humidity, and temperature, probably in that order of destructiveness.

Prints stored together must all be properly processed and washed. Never store unfixed stabilization-processed prints with fixed, washed prints. The stabilized print is literally saturated with hypo, which will contaminate the other prints.

Polaroid prints, when fully dry, have a protective "skin" that reduces out-migrations of harmful chemicals. Nevertheless, it's best to provide intervening layers of 100 percent rag paper or polyethylene between Polaroid and other prints, to be safe.

STORAGE MATERIALS

BEST:	Polyethylene envelopes Sealed metal storage box Near-freezing temperature 25–30% relative humidity
GOOD:	100%-rag-paper folders Polyethylene boxes Room temperature Low humidity
FAIR:	No envelopes High-quality fiber boxes Dry location
BAD:	Glassine Envelopes Wooden boxes Elevated temperatures Summer humidity
DISASTROUS:	Gummed envelopes Corrugated boxes Sunshine Basement humidity

PERMANENCE

BEST:	100%-rag mounts Dry mounting
GOOD:	Photo mounts Dry mounting
FAIR:	Photo mounts Photo adhesive
FAIR:	Masonite Wet mounting
BAD:	Cardboard Rubber cement Pressure-sensitive tape

Glassine envelopes and wooden boxes both contain chemicals harmful, in the very long run, to photographic emulsions.

High temperatures are bad, but high humidity is even worse. Use silica gel desiccant in a cloth bag. Check local chemical supply houses.

Use only baked-on enamels or epoxy paints on storage boxes. Look for polyethylene storage containers in housewares departments. All plastic boxes breathe somewhat, and so are not humidity-proof. Store in a dry place.

Fungus

Fungus may be a problem in tropical climates. High humidity (over 60 percent) encourages fungus growth on both the print and the mount. Fungus tends to dull otherwise bright, glossy, print surfaces. Prints treated with print-flattening solution are somewhat hygroscopic and are particularly vulnerable. Prints fixed in hardening fixers are more resistant to fungus than straight-hypo-fixed prints.

Although some forms of toning aid in resisting fungus growth, treatment of black-and-white prints in a fungicide is better. (No fungicidal treatment for color prints is currently available.) Spray-applied lacquers may help somewhat.

Stabilized Prints

Never mount a stabilization-processed print that has *not* undergone subsequent fixing and thorough washing. The paper is loaded with hypo and may mess up your dry-mounting iron. Heat may cause print browning. The print may inadvertently be stored with good prints and ruin them. Always fix and wash the print very thoroughly before mounting and/or framing it.

Frames

Permanence

There is no real surefire way to make and mount prints that will last forever. So let's be practical.

Dry mounting is probably the safest method. The meltable adhesive is relatively safe. The tissue-adhesive barrier protects the print from chemicals in the mount. So dry mounting on photo mounts is a very good procedure. Use only standard dry-mount tissue, not low-temperature wax types, for all but resin-coated papers.

Even better, use 100 percent rag, acid-free mounts. Leave at least 2.5 cm (1 in.) borders on the prints to minimize migration of chemicals to the image from the edges. Use only 100 percent rag overmats, too, dry-mounting them in position.

Never use corrugated cardboard or tablet cardboard for anything (except possibly mailing). Both contain high levels of harmful chemicals.

FRAMES

Some prints look nice displayed without framing. Very moody, low-key prints, for example, may be displayed frameless. But most photographic prints require a frame to project and contain the picture elements. A frame separates the picture from its surroundings, drawing attention to the subject matter.

Prints are two-dimensional. Frames for photographic prints should project the picture from the wall to gain attention. The plane of the picture should be at least an inch away from the wall surface.

A frame must surround the picture to define the artistic boundaries intended and to keep the viewer's eye from wandering to surrounding distractions.

The frame should not become an integral part of the overall image, as is often the case (intentionally so) with oil paintings. Both frame and mat should clearly focus attention to the photographic subject, not distract from it.

Frame Sources. Finding suitable frames or molding is difficult. Frame and molding stores carry very few acceptable styles. Art-supply stores and department stores often stock modular metal frames. Photo stores catering to serious photographers stock frames and mounts. If all else fails, write the manufacturers of photographic frames for mail-order catalogs or for names of dealers.

The next few sections describe both frames

Frameless frames

you can make (or have made) and frames you can buy.

Frameless Ideas

Some low-key bled work looks good frameless. But even frameless prints should be spaced away from the wall.

The simplest method entails gluing or taping two strips of ¾ × ¾ in. balsa stock or 1 × 2-inch pine to the mount back. Make the length of the top piece at least half the mount-board width. When hung (on two nails) the frameless mount seems to float off the wall.

For a more blocky, forceful approach, glue the mounted print to a sub-frame (see Strip Frame) or to a block of styrofoam. Or to a box bottom or cover the same size as the mount. Or to a 2.5 cm (1 in.) cork block. In all cases, paint the mount and edges black or wrap the edges with black photographer's tape. If the back is solid, cut two large holes for hanging.

Several concerns make frames that are actually frameless, or nearly so.

Nearly frameless frames have very, very narrow sides. The lip is extremely small. Whether the frame uses glass or not, the print or mounted print has to be a nice, tight fit or the edges will show. Frames of this type come in plastic or metal and are generally fairly expensive. They do look nice when properly made. Some hold the print or mount on only two sides, instead of four.

Some frameless frames are really just a clear plastic box. Insert the print and an inner box or block and the whole assembly looks much like a print on a block. The glossy sides and front tend to distract a bit, especially with dark, low-key work. With high-key work, the effect is very modern and clean. Cost varies, depending on quality.

Frame Styles

Frames for photographic prints must be simple and narrow, to contain but not distract. Ornate frames, wide frames, shadow-box frames, and the like should only be used for special effects. The print that needs special framing is so rare we will not cover it in this book. (The one most common exception is the photo-oil-colored portrait. These do look good in ornate frames.)

Frames that do not project the print—that is, space the image away from the wall—serve only as a kind of pseudomat (add-on) border.

In summary, photographic frames should be *simple* and *narrow* to *project* the print.

Materials. Suitable frames come in wood, plastic, and metal. Wooden frames can be stained, painted, or covered; plastic or metal

SUB FRAME

STRIP FRAME

L-SHAPED FRAME

RABBET FRAME VARIATION

frames should be used as is. Plastic frames are cheapest (and usually look cheap). Metal frames are pretty expensive, even poorly made ones.

Since wooden frames can be finished, and since home craftsmen can make frames of wood, most of the following discussions on frames apply to those made of wood.

Size. Frames come in many sizes. However, certain sizes are more suitable for photographic work. Since standard paper and mount sizes are 13 × 18 cm (5 × 7 in.), 20 × 25 cm (8 × 10 in.), 28 × 36 cm (11 × 14 in.), and 41 × 51 cm (16 × 20 in.), consider frames in these standard sizes.

Although you can trim prints to fit other frames—those intended for documents, watercolors, oils—such frames usually are too ornate or lie too flat against the wall to work well with photographic prints.

Color. Any frame color works as long as it's black. Start out with this rule. Use flat or satin black, not glossy.

Next, try white or gray. Advance to walnut or mahogany. Then experiment with colors, patterns, metallic finishes.

Always keep in mind that you do not want to distract from the print but merely to contain, or possibly enhance it. Black almost always works well.

Glass. Frames commonly found in department, discount, and dime stores use glass. Glass is neither necessary nor desirable for most photographic work. Glass reflects, glareless glass diffuses, prints stick to glass, glassed frames are difficult to hang, glass breaks. Most glassed frames do not project the print from the wall. Many glassed frames use common cardboard for backing, a material containing chemicals harmful to print emulsions. Plexiglas (plastic glass) collects dust and scratches easily. Plexiglas contains some chemicals harmful to print emulsions.

For protection, handling ease, and future storage, mount all photographic prints on acid-free material. Select glassless frames that accept the *mounted* print. However, if the print is extremely valuable, very fragile, or will be constantly exposed to sunlight (high ultraviolet), then use glass.

Moldings. There are many variations possible in frames, some of which are shown here.

(1) *Strip Frame.* Construct a sub-frame of ¾ × ¾ in. pine or balsa exactly the size of the mount.

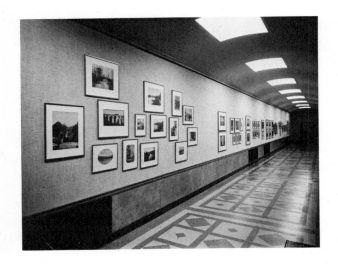

Examples of print grouping in a gallery situation. Installation photos of the exhibition *French Primitive Photography* at the Philadelphia Museum of Art.

Miter and finish ¼ × 1 in. or ⁵⁄₁₆ × 1⅛ in. strips. Buy this strip stock, called "lattice," from a lumber yard. Nail or glue the mitered strips to the sub-frame.

Insert the mounted print and glue or tape in place.

(2) *L-Shape Frame*. Select a contemporary *deep molding* from a frame and molding supply store. Very carefully miter the corners (cut at 45-degree angle) and drill pilot holes for finishing nails. Glue (white glue) and nail the corners while clamped in corner clamps (available from Sears, hardware stores, etc.). The cross-section of this frame is small, making corner joints both difficult and weak. This molding does not lend itself to any kind of specialty fasteners. Be sure the *inside* dimensions will accept standard-sized mounts.

Finish as desired. Insert the mounted print and tape in place with masking tape, from behind.

This type of frame covers the narrow borders formed by the enlarging-easel arms.

(3) *Rabbet Frame Variation*. Select a frame molding with .2 × 3.2 cm (¾ × 1¼ in.) face, or standard 1 × 2-inch lumber (actually ¾ × 1½ in. [.2 × 3.8 cm]). Miter the corners. Cut a 4 × 9 mm (³⁄₁₆ × ⅜ in.) rabbet on two passes

through the table saw. Nail and glue or dowel-pin or miter-pin the corners. Finish. Be sure the inside of the rabbett is dimensioned to accept a standard-sized mount.

Insert the mounted print and tape or glue in place.

Displaying Prints

Walls. The best wall color for print display is off-white. Large wall areas are best. Use large pictures on wallpapered walls; small ones get lost. Never hang a print on a mural-papered wall. Peg-board walls distract. So do paneled walls with strong grain patterns. Do not hang prints close to windows; the print is hard to see during the day. Look for a wall area that looks empty.

Furniture. Don't compete with decorative furniture, especially lamps, plants, and other tall items. Your prints deserve an uncluttered area. Hang large horizontal pictures above sofas or on long walls. Hang large vertical pictures between lamps or on tighter wall spaces. Be sure no furniture is where the viewer would stand. Treat large pictures as furniture when rearranging a room.

Be sure subject matter suits the decor of the room. Be aware of dominant colors when hanging color prints.

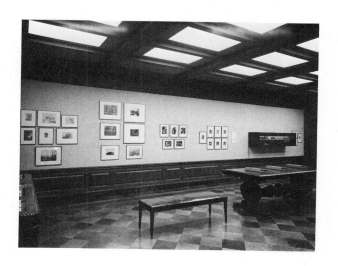

Groupings. Small pictures or pictures of related subjects often look best when grouped. Try arrangements on the floor before committing the pictures to the wall. Mark off with string on the floor the wall area to be covered. Observe proper viewing considerations for the individual pictures. Center groupings slightly above eye level.

Static, serene subject matter should be grouped in a fairly symmetrical, geometric pattern: rectangle, triangle, oval, or straight line. Arrange more active subject matter in more asymmetrical, dynamic patterns.

Gallery Area. Find a special place for a gallery for prints, not to be used as part of a room decor. An entry area is ideal. Or a wide hallway. Or one wall of a den or office. Or even an unused room, now to be a photo gallery. Do not choose a private area, like a bedroom, nor a work area, like a kitchen.

Viewing Rules. Place large pictures so the middle is a bit above eye level. Place smaller pictures at eye level.

Large pictures must be viewed from a distance, smaller ones up close; so use large pictures where furniture intervenes, small pictures in hallways and stairways.

Technically, proper viewing distance is a function of subject matter, focal length of camera lens used, and degree of enlargement. Practically, however, *image size* usually dictates *viewing distance.*

There are some exceptions to picture height. Place pictures lower if displayed in waiting rooms or the like where viewers are nearly always seated. Place lower if the subject matter is normally at ground level (flowers, small animals) or higher if usually found higher (flying aircraft). Place lower if furniture is of a low-silhouette design; higher if it is of tall or massive design.

Basic Lighting. Seeing requires light. You can use various intensities, angles, and colors to illuminate objets d'art, furniture, and other three-dimensional objects. Photographs, however, require bright, evenly distributed, white light. Flood the entire room with light for most satisfactory viewing. Pools of darkness or hot spots of light distract the viewer. Your best work, neatly mounted and framed, will go unnoticed because of poor lighting.

Existent Lighting. Whether the lighting is natural or artificial, be sure the viewer is not looking into either the light source or a reflection of the source. Don't place pictures alongside of windows or close to lamps, for

SIZE, DISTANCE, AND HEIGHT FOR DISPLAYING PRINTS

SIZE	DISTANCE	HEIGHT *
13 × 18 cm (5 × 7 in.)	30 cm (1'—hand-held)	1.67 m (5'6")
20 × 25 cm (8 × 10 in.)	61 cm (2'—arm's length)	1.67 m (5'6")
28 × 36 cm (11 × 14 in.)	1.22 m (4'—a chair between)	1.72 m (5'8")
41 × 51 cm (16 × 20 in.)	1.83 m (6'—from center of room)	1.78 m (5'10")

*From floor to center of picture.

example.

Be sure the viewer will not cast a shadow on the pictures.

If you are unable to change the lighting, be selective in picking a spot for that prized print. Check it out both in daylight and at night.

Adding Daylight. Overhead skylights would really be ideal if one were to design a gallery room. If this is impossible, one solid wall of windows might be next best, adjacent to two display walls. Windows on two walls, prints on the other two, might be even better.

Adding Lights. Ceiling lights placed about 1 m (3 ft) from a wall that is 2.4 m (8 ft) high will illuminate displayed prints from about a 45-degree angle. The lights should be white and diffuse (not spotlights). Diffuse lights cast soft shadows and add general illumination to the room.

Most of us don't own footcandle meters. An ordinary exposure meter (or built-in camera meter) will do. A pleasant light level is equivalent to 1/30 sec. at *f*/4 at E.I. 400 read off a piece of typing paper taped to the wall. A stop plus or minus (twice or half) is acceptable.

Unless you want to simulate a 1920's mansion full of Old Masters, forget about those little lights that fasten to the top of the frame.

They distract, and light unevenly.

Spotlights draw attention to a picture artificially. The picture should be able to do this without help. One print in a room certainly doesn't require a spotlight. Several prints in a room deserve equal lighting.

If the room lighting is low, try making your prints a bit on the light (underexposed) side and a bit contrastier. If the room lighting is high, make your prints darker (slightly overexposed) but of normal contrast.

Lighting Color. For black-and-white prints, lighting color is pretty much immaterial. Even toned prints look good in most normal lighting. It's a different story with color prints.

Most objects in our environment appear essentially the same color no matter what the lighting. Our minds compensate. Photographs encompassing a wide range of colors, however, will appear different under different lighting. Skylight accentuates the blues. Tungsten (incandescent lightbulbs) lighting favors the reds and yellows. Light dimmers and amber fixtures dull all but the oranges. Fluorescents vary, often accenting greens. Reflecting walls also color the light falling on the print.

Color prints are usually not as vivid (brilliantly colored) as are natural objects. Colors

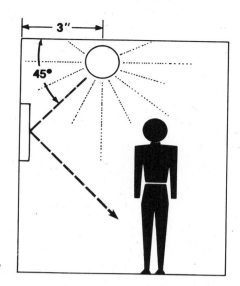

Lighting

will change from daylight to artificial light and may be objectionable, depending on the viewer and the subject matter. Generally, the changes are not bothersome.

Wall color is another story, though. Walls should be off-white, even grayish or beige. Bright white walls can make the print appear dull and washed out. Very dark or paneled walls, on the other hand, are often acceptable because the print appears to be very bright and vivid. Strongly colored walls usually cause objectionable color distortion and should be avoided.

Tungsten lighting causes less fading of colors with time than does sunlight or fluorescents. The latter both contain higher levels of ultraviolet light. Using protective glass or spe-

cial Plexiglas helps cut down ultraviolet rays. This added precaution is really not warranted, however, unless the print is in strong sunlight or very high-level fluorescent lighting around the clock.

MOOD CHART

Here are some ideas to stimulate your imagination. The mount and frame suggestions are by no means the only, nor possibly even the best, way to handle the subject. But the suggestions will, it is hoped, start you thinking about the mood and the effects you wish to communicate to the viewer.

Why not try making a mood chart for your ten favorite prints?

MOOD CHART

MOOD	TYPICAL SUBJECT	MOUNT AND FRAME
Action	Race Car	Gray horizontal parallelogram, no frame
Still	Still Life	Double mat (black and gray) black frame
Colorful	Birds (color print)	Gray mat, black frame
Bright	Glassware (contrasty print)	Silver mat, black frame with silver lip
Dismal	Shanties (mid-key print)	Narrow gray mat, black frame
Large	Skyscraper (vertical print)	Narrow gray mat, gray frame, hang high
Small	Frog (small print)	Wide gray mat, black frame, hang low
Close-up	Insects (round print)	Gray mat, square black frame
Distant	Airplane	Black binocular mat, black frame
Hot	Desert (toned orange)	Full mount, natural frame
Warm	Portrait (toned sepia)	Cream mat, walnut frame with black lip
Cool	Moon (toned blue)	Cream mat, black frame
Cold	Snow (contrasty print)	White mat, white frame with black lip
Submersed	Fish (toned blue-green)	Black horizontal oval mat, black frame
Wet	Rainy Street (contrasty)	Gray mat, black frame
Serene	Mountain Lake	Narrow gray mat, frame-ruled border, black frame
Mysterious	Fog (diffused print)	Gray mat, gray frame
Dramatic	Theater (low-key)	Full-mount, black frame
Frightening	Storm (low-key)	Black mat, black frame
Intimate	Couple (horizontal)	Gray mat, black frame
Private	Sleeping Nude	Black keyhole mat, black frame
Together	Family Reunion	Narrow gray mat, long black frame (20 × 51 cm; 8 × 20 in.)
Separate	Family Tree	Gray background mat, black frame
Soft	Portrait (vignette)	White oval mat, white frame
Hard	Portrait (low-key)	Full-mount, flush or bleed, no frame
Formal	Wedding	White mat, print-ruled border, black frame
Glamorous	Portrait (diffused)	Gray vertical mat, black frame
Sensual	Figure (high-key)	White horizontal mat, white frame with black lip
Unstable	Balanced Rock	Gray vertical parallelogram, no frame
Stable	Brick Wall (bled image)	Full mount, black frame
Happy	Birthday Party (color print)	Narrow gray mat, black frame
Sad	Starving Child (mid-key)	Full mount, black frame
Old	Musket	Découpage
New	Computer	Photosculpture
Grand	Palace Guard (oil-colored)	Covered overmat, walnut frame with gold lip, hang high
Lowly	Rats (small print)	Gray mat (wider on top), black frame, hang low

Annotated Bibliography

Books

There are a number of books we can recommend that should serve as a basic photo library. Our criterion for selection is based on educational function. Information presented in these books is useful to serious photographers and they are the best in their field as of this writing.

Boyd, Harry, Jr. *A Creative Approach to Controlling Photography*. Austin: Heideberg Publishers, Inc., 1974. Boyd's approach is no-nonsense but emphasizes the creative aspects of photography. Lots of line drawings and illustrations. Good section on creative techniques. Heavy emphasis on darkroom manipulation.

Eastman Kodak Co. *Adventures in Color Slide Photography*. Rochester: Eastman Kodak Co., 1976. An excellent survey of the use of color transparency material and a good idea-book for creative color work. Illustrated entirely in color, the book is a good teaching or learning tool.

Eastman Kodak Co. *Encyclopedia of Practical Photography*. Garden City, NY: Eastman Kodak Co. and Amphoto, 1977. 14 volumes. This series will prove invaluable to both beginning and advanced photographers as a continuing reference work. Very well-executed illustrations and lucid explanations. Highly recommended.

Eastman Kodak Co. *Kodak Professional Photoguide*. Rochester: Eastman Kodak Co., 1975. This small spiral-bound guide is loaded with information, charts, computers, and tables that should prove essential to serious photographers. Information on films, exposure, filters, flash, cameras, and lenses is included. Of special merit are several circular computers for such things as existing-light exposure calculations, color temperature, depth of field.

Eastman Kodak Co. *Professional Portrait Techniques*. Rochester: Eastman Kodak Co., 1974. Softbound. A superior, inexpensive book on portraiture. Especially helpful is the section dealing with types of lighting. Another noteworthy section is on makeup for portraiture. A must for those interested in "people" pictures.

Frechen, Wolfgang. *Modern Photographic Techniques*. New York: Crescent Books, 1976. A well-thought-out book of general photographic interest.

Hedgecoe, John. *The Book of Photography*. New York: Random House, 1976. A large-format book, lavishly illustrated. A soup-to-nuts survey of photographic equipment, techniques, processes, and art. The book is an excellent guide for the beginner, as well as a ready-reference for the experienced professional. Curiously lacking in detailed description of color applications.

Isert, G. *The Art of Color Photography*. New York: Van Nostrand Reinhold Co., 1971. Currently out of print, but still available in some areas, this book covers a broad scope. Isert discusses color photography in all aspects. You'll probably find the book somewhat curiously arranged and a bit cutesy (attempts at humor in illustration are sometimes a bit overdone), but the content is solid stuff. Heavily illustrated, it can serve as an excellent introduction to color.

Mante, Harold. *Color Design in Photography*. New York: Van Nostrand Reinhold Co., 1972. Outstanding in both subject matter and manner of presentation. Mante explains and illustrates the use of color, contrasts, and the impact of color in photography. The best source available to learn about the use of color as an artistic tool. A "must" book.

Morgan, Douglas O., David Vestal, and William Broecker. 15th ed. Dobbs Ferry, NY: Morgan & Morgan, 1973. A complete book of 35 mm photography, covering both rangefinder and SLR cameras.

Nibbelink, Don. *Picturing People*. Rochester: Eastman Kodak Co., 1976. A solid base of information on formal and informal portraiture, lighting, posing, and effects. Heavily illustrated.

Purves, Frederick, ed. *The Focal Encyclopedia of Photography*. London: Focal Press, 1972. 2 volumes. Desk Edition (single volume, 1699 pages) published in the U.S. and Canada by The McGraw-Hill Book Co. The bible of photography. From simple to complex, every subject is explained clearly and concisely. An absolute must. If you own no other photo books, get these.

Q, Pat and Mike. *The Manual of Slide Duplicating*. Garden City, New York: Amphoto, 1978. The most up-to-date book on the subject. Information presented is based on years of professional experience. Black-and-white and color illustrations abound.

Rothschild, Norman. *Making Slides, Duplicates and Filmstrips*. 3rd ed. Garden City, NY: Amphoto, 1977. A thorough work on duplicating. Although a bit dated now, still a source of sound advice on a tricky process.

Snyder, Norman, ed. *The Photography Catalog*. New York: Harper & Row, 1976. This catalog is more than a mere compilation of facts and figures. It's an entertaining and informative book that debunks a lot of the myths of photography, such as the supposed difference in quality among major lens lines. Well worth reading.

Swedlund, Charles. *Photography*. New York: Van Nostrand Reinhold Co., 1974. A basic college text, well illustrated, but dry reading. Lots of technical explanations

and illustrations for those so inclined. Very good section on darkroom work for beginners.

Magazines

Camera 35. This magazine is devoted to 35 mm photography, with heavy emphasis placed on the esthetic aspects. It is written for serious amateurs. Little advertising included. Gets a bit pretentious at times by indulging in artistic excess, but its valuable interviews with well-known personalities in the photo industry are interesting and illuminating. Not particularly oriented to technique or how-to-do-it. Equipment tests are not as elaborate as those of either *Popular Photography* or *Modern Photography,* but are more commonsensical and practical. Subscriptions are available at discounts.

Modern Photography. The greatest strength of this mass-audience monthly is its detailed testing of photo products, especially cameras and lenses. *Modern* contains a high percentage of advertisements, but not quite as high as that of *Popular Photography.* Does not print equipment reports on products that fail its tests. Places heavy emphasis on tests of color films. Editorial copy is somewhat limited, but monthly columns do contain a good deal of useful information. Little copy devoted to composition, esthetics, and the like. Subscriptions are available at considerable discounts.

Petersen's PhotoGraphic Magazine. The newest of the major photo periodicals, *PhotoGraphic* blends features of the three other publications listed here. Little emphasis placed on test reports of new equipment, but much on projects, how-to-do-it techniques, and creative darkroom work. Aimed at serious amateurs. Good color reproductions and little advertising. Back issues are of particular merit, for they contain a host of articles suggesting creative techniques to photographers. Petersen's actively solicits work and articles from amateurs. Subscriptions are now becoming available at discounts.

Popular Photography. This weighty monthly magazine is probably the best-read photo journal in the U.S. Its strong points are in-depth technical features on new equipment, films, and accessories. Color reproduction is outstanding. Nearly half of all copy in any typical issue is comprised of ads from major photoequipment mail-order firms or photo products distributors. Editorial copy and monthly columns are skimpy and somewhat variable in the utility of material presented; nevertheless, contributing editors are top-flight. All in all, worth reading; but don't expect how-to-do-it articles or much copy concerning itself with composition, theory, or esthetics. Subscriptions are available at substantial discounts.

Specialty Photo Publications

Recent years have seen a proliferation of specialized photo publications in soft covers selling for $2 to $6 or so. Some of these booklets are general in nature, others concentrate on one subject. Many are published by the major photo magazines. They may appear as quarterlies, semiannuals, annuals, or title releases at various times during the year. While most contain at least some useful information, many merely reprint articles that appeared in past issues of major magazines.

Notably among these publications has been a series of specialty guides published by the Petersen Publishing Company. Of particular merit are *Petersen's Basic Series* and *How-To PhotoGraphic Library,* covering such subjects as lighting, creative darkroom techniques, a how-to book, special in-camera effects, and so on.

Another publication that contains useful information is *35 mm Photography.*

A wealth of ideas about print display is contained in *Book X-6* (1973) by Royal Dossett. This thin (60-page) book is a goldmine of information on mounting and framing. If you want a copy, write to Mr. Dossett at 2793 Pheasant Ave., Excelsior, MN 55331. The cost will be around $3.

We suspect that softbound magazinelike speciality books will increase in number in the near future. How well they will serve the educational needs of photographers is yet to be seen.

Free or Inexpensive Photo Information That Has Proven Useful to Us

Edmund Scientific Company Catalog. 222 Edscorp Bldg., Dept. PG, Barrington, NJ 08007. This catalog is packed with all sorts of science-and-technology gadgets, surplus, and items of Edmund's own design. One section is devoted exclusively to photography. It's free for the asking.

Guide to Electronic Flash. Honeywell Photographic Products, 5501 S. Broadway, P.O. Box 1010, Littleton, CO 80120. While this free booklet mainly describes Honeywell flash systems, several pages are devoted to electronic flash theory and practice. Well worth reading.

Hasselblad Booklets. Braun North America, Cambridge Parkway, Cambridge, MA 02142. Hasselblad, makers of prestige 2¼″ × 2½″ cameras, has prepared a series of booklets on a variety of photo topics. Each booklet is handsomely printed and contains much good information. Of particular interest are the booklets covering child photography, nature, composition, and close-up and macro work.

Index to Kodak Information. Eastman Kodak Co., 343 State St., Rochester, NY 14650. Here are listed the hundreds of Kodak publications available, priced from 5¢ to $15 or so, from the well-known *Here's How* series to books on supertechnical data.

International Photographic Books Catalog. International Photographic Books, 393 Seventh Ave., New York, NY 10001. This catalog, which lists virtually every photo book in print, fills the gap left when Laurel Photographic Books closed. It is a handy reference index.

McDonald Photo Products, Inc., 1121 Gemini Lane, Dallas, TX 75201. Write for free catalog of things useful to print mounting and framing.

Picturing America—A Student's Guide to Traveling With a Camera. Minolta Corp., 101 Williams Drive, Ramsey, NJ 07406. This informative booklet describes the techniques that turn travel photography into a pleasure rather than a pain. The authors make film and equipment recommendations.

Porter's Catalog. Porter's Camera Store, Inc., P.O. Box 628, Cedar Falls, IA 50613. In approximately 110 pages of a newspaper format, this free catalog illustrates and describes virtually all the accessories currently on the market. Many items are unique to Porter's. Prices are reasonable—not the cheapest, not the most expensive—but Porter's service is first-rate and they've always been helpful.

Shutterbug Ads. P.O. Box 730, Titusville, FL 32780. Monthly, by subscription. The 40–50 pages of this newspaper format are crammed with every type of camera, lens, and accessory. It is fascinating reading even if you are not a collector. Since most advertisers are private parties who are collectors or swappers, the condition stated for most equipment is very likely accurate and the dollar value reliable. Some excellent buys can be had in used quality.

Spiratone Catalog. Spiratone, Inc., 135-06 Northern Blvd., Flushing, NY 11354. Spiratone markets a wide variety of lenses, accessories, and filters, as well as darkroom and general photoequipment. Their catalog is full of gadgets and is fun to look through, even if you don't intend to buy.

Vivitar Booklets. Vivitar, Inc. (formerly Ponder & Best), 1630 Stewart St., Santa Monica, CA 11377. Vivitar offers three booklets that should be of interest. Just write and ask for them.

How to Photograph Auto Racing is a well-written booklet, with some detailed information to make your auto racing pictures come alive.

How to Photograph Sports is an informative publication, written by pros, giving tips on photographing a number of sports.

How to Use Multiple Flash, by Peter Gowland, is a study of multiflash by a master.

In addition to the industry sources listed above, most monthly photo magazines list a page or so of photographic equipment companies who offer free or inexpensive information.

Glossary

Accent color—a secondary color of objects in a scene that highlights or goes well with the color of main subjects.

Acutance—a measure of image sharpness. In essence it is a measure of the sharpness of the edges or boundaries between different hues or intensities of gray contained in a print or negative.

Ambient light, also **available light**—existing light not supplemented by artificial means.

Angle of coverage, also **angle of view, angular field**—an angle expressed in degrees of the coverage of a specific lens across the film diagonal. Therefore, a wide-angle lens of 28 mm in 35 mm film size will cover approximately 74 percent across the diagonal. A so-called "normal" lens of 50 mm will cover 46 degrees across the diagonal.

ANSI. See **ASA.**

Aperture-priority metering—an automatic exposure system in which the user selects the aperture and the camera system selects the appropriate shutter speed. Usually shutter speeds are infinitely variable in this type of system, which is used in most automatic cameras. See also **Automatic camera.**

ASA—American Standards Association, the old name of the American National Standards Institute (ANSI). "ASA" followed by a number designates U.S. standard rating of the light sensitivity of films and photographic papers. See **DIN.**

Automatic camera—a camera whose functions are controlled either mechanically or electrically to a point where the camera performs most, and in some cases all of the functions of exposure control. Decisions on proper exposure are made by programs built into the camera system; the photographer merely focuses and presses the shutter. Some cameras called "automatic" are in reality semiautomatic, for the photographer must select either the f-stop or the shutter speed, while the camera selects the other function to achieve proper exposure. See also **Aperture-priority metering** and **Shutter-priority metering.**

Automatic diaphragm—a diaphragm, built into the lens, that remains wide open to focus and set the exposure meter. As the photographer presses down on the shutter release, a mechanical pin is depressed or an electrical contact is made to close the diaphragm opening to the preselected size (f-stop). As soon as the film has been exposed, the mechanical or electrical contact is disengaged and the diaphragm returned to the fully open position. In most cameras this all happens in a fraction of a second and is hardly noticeable to the human eye.

Available light. See **Ambient light.**

Barrel distortion—an aberration characterized by outward curvature of vertical lines near the edges of film or of a print.

Brightness range. See **Lighting ratio.**

Camera shake—the movement inherent in hand-holding a camera which can have an adverse effect on the photographs. Slower shutter speeds record more shake than high shutter speeds. A rule of thumb is to try to use a shutter speed equal to the reciprocal of the focal length of the lens in use. For example: 50 mm lens—1/60 sec. or faster; 135 mm lens—1/125 sec. or faster.

Cassette, also **cartridge**—a lighttight metal or plastic container for film. Film for 35 mm cameras generally comes in cassettes. Some cassettes are reusable, some are not. The term "cartridge" is mostly used for the drop-in film container used with instant-load cameras.

CdS (Cadmium Sulfide) light meter—a photoelectric device employed on many modern exposure-metering systems, either built-in or separate. Compact and sensitive to all but very low light levels, it has replaced earlier types of meters that used other power sources.

Chroma—the intensity of a specific color. It is also defined as the combination of saturation and hue.

Coatings of lenses—microscopically thin layers of chemical compounds affixed to the surfaces of modern lenses to increase the amount of light transmitted through the lens to the film. For example: An uncoated 100 mm $f/2.8$ lens might transmit 60 percent of the light striking it to the film, while a 100 mm $f/2.8$ coated lens might transmit nearly 90 percent to the film. Coatings come in single- or multiple-layer varieties (see *Multicoating*). Coatings impart magenta or amber color casts to the lens glass, but the apparent color in no way affects the color rendition in the picture.

Color balance—a term usually applied to color printing. It refers to the use of filters to achieve a natural or, in some cases, desired balance of hues in a print. In transparency films, the term refers to the slight differences in color rendition between one type or brand of color film and another, which are especially noticeable in projected slides.

Color cast—an overall bias toward one particular color in a picture. Taking photographs at certain times of the day induces color casts naturally: Late afternoon tends to produce yellowish or gold casts in pictures, while overcast days produce bluish tones. Strong reflections from colored surfaces can produce color casts in the picture, too. Slight differences in color rendition between one type of color film and another is very evident in projection slides.

Color harmony—pleasing balance of color in which various hues are not fighting with one another for dominance.

Color saturation—a term for describing purity of color. Colors that appear to be deep and rich are said to be "fully saturated." Emphasis on it is a subjective esthetic choice on the part of the viewer. Underexposing color transparency film slightly or overexposing color negative film will result in more saturation than would normally result if exposure were made at the meter setting. Some films tend to produce more apparent saturation than others because of their higher contrast levels.

Color separation—a method for printing color, usually employed by magazine or book publishers, whereby a color photograph is photographically separated into its primary (or secondary) colors, each of which is printed separately to make the reproduction. It is an expensive but very accurate process. A typical 20 × 25 cm (8″ × 10″) color separation might cost over $150.

Color temperature—a system by which the spectral quality (color) of light is measured. Each source of light has a specific color temperature, measured in degrees Kelvin. The usual range of color temperatures in photography is from 3200 K for studio flood lamps to 5000–6000 K for daylight or electronic flash approximating daylight. Since each color film is formulated to record color accurately only within specific ranges of color temperatures, it is essential that film and light source match. This can be done by either using the film specifically balanced for the light source (e.g., tungsten film for 3200–3700 K tungsten light sources) or by using appropriate color filters. See also **Kelvin.**

Compact camera—a term now in vogue to describe 35 mm SLRs that are appreciably smaller and lighter than previous models. The Olympus OM's, the Canon "A" line, the Nikon FM, the Minolta XD-11, the Pentax ME, and the Konica TC are a few of these new compact SLRs.

Complementary colors—two colors which when added together result in white light.

Composition—the organization of elements within a picture. See also **Mass balance.**

Contrast (film)—limitations in the ability of various films to render a full range of tones between black and white. High-contrast black-and-white film renders only the black and the white. High-contrast color film poses problems, for color cannot be reproduced accurately in high-contrast situations: Light areas tend to wash out toward white, and dark areas go black without much detail or color gradation.

Contrast (scene)—differences in tonal values, referred to as contrast in composition. "High contrast" refers to a scarcity of tones between light and shadow. See also **Lighting ratio.**

Cropping—a term usually associated with darkroom work. It describes the technique of selecting for printing only a portion of the picture projected on the enlarger easel. Composition can be improved by cropping extraneous details from a scene.

Daylight color film—either negative or transparency film balanced to reproduce colors accurately in daylight. Usually balanced for 5500–6000 K, daylight film will also work with electronic flash and blue flashbulbs.

Depth of field—the distance between the nearest objects and the farthest objects that a lens records with equal apparent sharpness. Depth of field is controlled by and varies with the aperture, the subject's distance, and the focal length of the lens.

Diaphragm—in adjustable cameras, a hole of variable size made by a set of metal blades in the form of an iris, mounted either between the glass elements inside a lens or behind the lens. Diaphragms are calibrated in numerical sequence (see *f*-stop) to admit precisely graduated amounts of light. Usually "stopping down" a lens—that is, making the hole smaller—or opening up the lens, is achieved by turning a ring on the lens barrel.

DIN—initials that stand for the West German standards organization, Deutsche Industrie Norm, which set up a measurement standard for film sensitivity. Its ratings are used in most European countries. ASA is the United States equivalent of DIN. See also **ASA.**

Double exposure—exposure of two pictures on the same film frame. Double or, for that matter, multiple exposures have become difficult to achieve in most cameras by mechanisms constructed to guard against more than one exposure being made. Currently, however, cameras with provisions for making intentional multiple exposures are being marketed.

Eighteen-percent (18%) reflectance—an approximate average of the reflectance of a typical daylight scene. Virtually all reflected-light exposure meters (all built-in camera meters) are calibrated to respond to all photographic scenes as if they reflected 18 percent of the light striking them. Photographers should adjust exposures if the scene is appreciably darker or lighter than an average daylight scene, since meters are "idiots" that can do only what they are programed to do.

Electronic flash. See Strobe.

Emulsion—a thin layer on film, usually of gelatin containing light-sensitive silver halide crystals. Color film has three individual emulsion layers, each sensitive to a different primary color. These three layers, when exposed by transmitted light, together make up a full-color-range picture or negative.

Ever-ready case—a leather or vinyl case covering only the camera and lens. Many consider it a bother and more trouble than it is worth.

Expose—to subject film to light.

Exposure—the combination of *f*-stop and shutter speed that will subject film to light in such a way as to produce an image. See also **Exposure latitude, Exposure meter.**

Exposure latitude—the range of exposures on either side of the "correct" *f*-stop/shutter-speed combination that will result in acceptable pictures. This range varies by film type. Deliberate exposures at other than the values indicated by an exposure meter can alter the impact of the final picture.

153

Exposure meter—a device used to determine the correct amount of light needed to produce a negative or transparency that contains the full range of tones and hues present in the original scene.

Extension tubes—tubes attached between the lens and the camera body to make possible closer focusing than would be possible with the lens alone. A drawback is that with an extension tube in place, a lens can only focus within a very narrow range, sometimes measured in inches, and cannot focus at infinity.

Film speed—a designation of a film's sensitivity to light, measured by the ASA and DIN scales (see **ASA, DIN**). Most commonly used color and black-and-white films range from ASA 25 to ASA 400 (DIN 15 to DIN 27). Note that doubling the ASA number increases sensitivity by 100 percent, or one f-stop.

Filter factor—a designation of how much light a given filter absorbs. For example: An 80B filter used to balance the color of a 3400 K light source (studio lights) when using daylight film has a filter factor of 4. This means that a correct exposure needs four times the amount of light—an increase of two f-stops—to make up for the filter's absorption of light. From our example, it is obvious that to find out how much to increase exposure when using filters, simply divide the filter factor by two. With almost all behind-the-lens meters, this is done automatically for you. See also **Neutral-density filter.**

Flare—a veiling or masking effect that reduces contrast and desaturates color. It is caused mostly by skewed rays of light entering the lens and bouncing off unblackened mechanical components. Lens coatings of various materials and good blackening of lens components minimize flare, as does the use of a lens hood (sunshade). See also **Lens shade.**

Focal length—the distance between the film plane and the optical center of a lens. Confusing to some is the fact that two lenses with identical *physical* length can be of vastly different *focal* lengths because of the construction and design of the particular lenses.

Focal-plane shutter—a mechanism comprised of either one or a pair of curtains which in traveling across the film's focal plane provides a variable slit through which light passes to the film just behind. It eliminates the need for shutters in each interchangeable lens. See also **Leaf shutter.**

Frame—(a) one individual section of film of a designated size: A 35 mm film's frames measure approximately 24 mm × 36 mm (1″ × 1½″); (b) in compositional terms, the process of selecting the elements one wishes to photograph in a camera's viewfinder (see *Cropping*); (c) the boxlike outer construction holding a backing board, a picture with or without mount and/or mat, and (optionally) glass, together with suitable hooks or support for hanging or other display.

f-**Stop**—a setting on the lens diaphragm. The larger the *f*-stop, or *f*-number, the smaller the diaphragm opening; the smaller the number, the larger the opening. This is because *f*-stop numbers are really fractions arrived at by dividing the effective diameter of the lens into the focal length. Lenses are usually designated by their focal length and largest *f*-stop; therefore, a 50 mm *f*/1.4 lens is one with a focal length of 50 mm and a maximum *f*-stop of *f*/1.4.

Gaffer tape—very handy, strong, cloth-reinforced tape about two inches wide, used to tape lights, scenery, and other items. It is indispensable in the studio and on location.

Grain—suspended crystals of the silver halides that actually make possible the recording of an image on film. All films have grain, which appears as chunks of color or as dark spots. Some grain is more noticeable than other. Big enlargements make grain more noticeable; how noticeable is subjective.

Guide number—a number used to determine the *f*-stop to be used with a specific flash-unit/film combination. In addition, flash units are generally rated by a guide number against a specific film. To find the proper *f*-stop for electronic flash or flashbulb exposure, divide the flash-to-subject distance into the Guide Number (GN). For example: If your flash with ASA 25 film has a GN of 56, and flash-to-subject distance is 10 feet, then $\frac{56}{10} = f/5.6$. Be careful that the guide number you use is the correct one both for the film in the camera and for the flash you are using.

Guide rails—polished rails upon which the film travels in some camera types, such as 35 mm

cameras. They are located above and below the shutter opening at the film plane. They should not be touched.

High-key—a type of lighting where most areas of a picture lack significant detail. The overall picture is lighter than an average exposure would be. Used extensively in fashion illustration, high-key lighting can convey a sense of lightness, delicacy, or happiness.

Highlights—the brightest parts of a picture. As a rule, in metering for exposure, slide film should be exposed to retain highlight detail.

Hue—a specific variation of a specific color. See also **Chroma, Shade,** and **Tint.**

Incident light—light falling directly on the subject. Some writers insist incident-light measurement is the only correct way to meter exposures. Many hand-held meters provide for incident-light measurement by pointing the meter toward the camera from the subject position. See also **Reflected light.**

Infrared film—film, either black-and-white or color, that is only sensitive to infrared and not to visible light. Strange and unpredictable results can occur when using these films. They have no ASA ratings.

Inverse-square law—the natural law, discovered by Johannes Keppler, that the intensity of light is inversely proportional to the square of the distance between the subject and the light source. Thus, by *doubling* the distance between the subject and the light, one reduces the light to a *quarter* of its effect. Four times the distance reduces the original illumination to $1/16$ its original intensity. See also the chapter on composition in *Photography: Composition, Color, Display.*

Kelvin—a means for measuring the quality of light with regard to its spectral (color) properties. Color temperature of light is measured by degrees on the scale named for W. T. Kelvin. See also **Color temperature.**

Latent image—the invisible image contained on exposed but undeveloped film. There is a high probability that latent images change if not developed promptly. This is especially true of color films.

Leaf shutter—a type of shutter found in many cameras, consisting of a series of blades that open or close in a manner similar to that of a lens diaphragm. Its advantage is that it can be synchronized for electronic flash at all shutter speeds; its disadvantage, that it is difficult to manufacture cameras with leaf shutters and interchangeable lenses. See also **Focal-plane shutter.**

Lens cleaning—an equipment-maintenance process that should be carried out gently and only when really needed, since lenses are coated with relatively soft chemical compounds. Never use abrasive materials or fluids. Contrary to some advice, silicon-impregnated cloth is not recommended for cleaning lens surfaces, as it can leave a residue on the glass surfaces that can damage them over a period of time.

Lens shade—a metal or rubber shade or hood attached to the front of a camera lens to keep light that is outside the picture area from entering the lens and thus causing flare, among other things. Caution: Each lens shade is designed to work only with a lens of a specific focal length; be sure the lens-shade/lens combination is compatible. This is critical when using wide-angle lenses. See also **Flare.**

Lighting ratio—a term referring to the ratio of light in the lightest portion of a scene to that in the darkest. If the lightest area is three *f*-stops brighter than the darkest, the lighting ratio would be 3:1. Most modern black-and-white films can handle a wider brightness range than color films; for instance, with a brightness range beyond 8:1 it would be very difficult for color films to render full detail at both ends of the range. See also **Contrast.**

Low-key—a scene in which dark tones are of central importance. Shadowed details are particularly important here, and exposure metering should include them. Low-key lighting is especially effective with masculine subjects or when a brooding or heavy effect is desired.

Macro—a term used in dealing with image magnification expressed in terms of reproduction ratios. Macro range is generally from about half life size to about ten times life size. Thus an object photo-

graphed at life size, or 1:1, will appear exactly its own size on the film. A 2.5-cm coin would take up 2.5 cm of the film. (Magnification greater than 10× calls for a microscope and the technique of *photomicrography*.) Special problems occur in making larger-than-life photographs. Of particular concern is flatness of field. Special macro lenses are designed for use with ordinary cameras to reproduce images at high magnification with flat field (no outward or inward curving near the edges). Normal photographic lenses, even those of the so-called close-focus variety, are not designed for critical work in the macro range. The second problem is depth of field or, more precisely, lack of depth of field—the sharp-focus zone is measured in millimetres. This argues against hand-held macro work, because the slightest camera or subject movement can be disastrous.

Mass balance—where a scene is viewed in terms of its basic physical elements and a number of masses become apparent. Good composition dictates that, unless you have a specific reason to ignore it, the most pleasing composition can be achieved by a balancing of masses. A large unimportant mass can distract from the picture's main theme; so some way should be found to subdue its effect. It can be said that mass balance is the composition of a scene so that physical masses work in harmony and reinforce the theme of the picture. See also **Composition.**

M-synchronization—an electrical circuit built into most cameras that allows for a very short delay in time between opening of the shutter and firing of an M-class flashbulb. Since such bulbs burn, it takes a few milliseconds for them to reach maximum intensity, and therefore the delay is built into the system that uses them. Be sure to use proper synchronization if your camera has a selector switch. See also **X-synchronization.**

Multicoating—a process through which multiple layers of chemical compounds are applied in microscopically thin layers to one or more surfaces of a lens. Aimed at increasing light transmission and reducing flare, the process thus improves overall optical performance of lenses.

Negative—an image on film (or paper) in which the tones are reversed and from which a positive image can be printed; also, the film bearing such an image. Negatives can be either black-and-white or color. Any color film whose name ends in the word "color"

is a negative film—Fujicolor, Kodacolor, Agfacolor, etc.

Neutral-density filter—a filter that uniformly reduces the amount of light entering a lens, without affecting its quality. For example, using fast film at the beach might demand the use of a neutral-density filter to counteract overexposure. N/D filters, as they are known, are calibrated in series—such as N/D 2 or N/D 4—to indicate how much light they will absorb. See also **Filter factor.**

Normal lens—a lens that "sees" approximately what the eye sees. For 35 mm cameras, lenses between 50 mm and 58 mm are "normal" lenses. For 2¼" × 2¼" cameras, lenses in the range of 75–80 mm focal length constitute normal lenses.

Optical distortion—a range of defects in either design or construction of a lens that distorts or degrades the image produced. To some extent, all lenses have degrees of optical distortion, but the better ones are corrected to a point where distortion is eliminated as a practical concern to the photographer.

Overexposure—a condition in which too much light strikes the film. Resulting effects on negatives and slides are opposites: Overexposure in color slides will result in too-light, washed-out-appearing transparencies and loss of detail; in both black-and-white and color negatives, density build-up in shadows can present problems in printing and, if grossly overexposed, prevent printing. See also **Underexposure.**

Panning—a technique whereby the photographer follows along with a moving subject with his camera, in order to arrest motion.

Photomicrography—the technique of using a microscope for making large images of extremely small things. See also **Macro.**

Pincushion distortion—a distortion, apparent at the edges of a picture or negative, in which there is a noticeable concave appearance to vertical lines. This type of distortion plagued early zoom lenses.

Positive—a transparency or print that in effect is an actual picture with correctly distributed tonal

values: Dark objects are dark; light ones, light.

Posterization—a technique used with either black-and-white or color materials, whereby a high-contrast negative is made for each main density and/or color an an image and then used singly or together in a composite to produce a final abstract print.

Primary colors—three portions of the spectrum, each representing a third of the visible spectrum, that produce white when combined. The primary colors of light are red, green, and blue. All other colors can be mixed from these.

Rangefinder—a device built into most quality cameras to measure distance from film plane to subject.

Reciprocity failure—loss of accuracy in a film's color rendition. Under normal conditions, photographic film acts in accordance with established tolerances. However, when exposed to very low light levels and, to a lesser extent, to extremely high levels not encountered in everyday picture-taking, film reacts differently. Then film must be exposed for a longer time than a meter indicates because the film is less sensitive to these extremely high and low light levels and the meter does not take this into account. For most films, 1/1000 sec. to 1 sec. presents no problem. Beyond these ranges, up to four f-stops more exposure is needed. Consult the film's data sheet for specific instructions.

Reflectance. See **Eighteen percent reflectance.**

Reflected light—light reflected from a photographic subject. Most exposure-metering systems read reflected light. See also **Incident light.**

Reflector—any surface that reflects light. Reflectors can be constructed of cardboard, metal, cloth, or other materials. They can add light to a scene and can increase the amount of light reaching the subject from the principal light source. A good use of simple reflectors is to distribute a bit of the light into the shadow side of an object.

Reflex camera—any camera designed to permit viewing through the lens.

Resolution—a term used to describe the image-forming qualities (resolving power) of a photographic lens. Also termed "sharpness," it is measured in lines per millimetre.

Reversal film, also **transparency film** or **slide film**—film, usually color, that turns into a positive finished picture after processing.

Sensitivity—a measure of any film's ability to record images, given a specific exposure to light.

Shade—a painter's term for the color gradation visible when a pure color alters as it becomes darker (black added). See also **Tint.**

Shutter-priority metering—the system in automatic cameras whereby the user chooses the shutter speed and the camera adjusts to the appropriate lens opening. See also **Automatic camera.**

Side lighting—placement of the main lighting directly to the side of the subject. This produces strong illumination of half the subject and little, if any, of the other half.

Silver halide—a chemical compound that is light-sensitive and effects the production of a latent image on film.

Spectrum—the total range of electromagnetic energy. Only a portion is visible to the human eye; this "visible spectrum" is the range of colors from red to blue that is seen when white light is dispersed into a rainbow by the atmosphere or by a prism.

Strobe, also **electronic flash**—an electronic device that produces a high-intensity, short-duration light of a controlled nature for photographic illumination. See also the chapter on accessories in *Photography: Buying, Choosing, Using.*

Teleconverter—a device fitted between camera body and lens to increase the focal length of the lens. Teleconverters come in 2× and 3× varieties.

Thyristor—an electronic circuit designed to conserve energy in electronic flash units. It permits very fast recycling times—as little as one third of a second.

Tint—a painter's term for a color gradation resulting when a pure color is lightened or desaturated (white added) and the color changes. See also **Shade.**

T-stop—a measure at the film plane of the value of the light actually transmitted through the lens to the film. This can differ greatly from the maximum marked *f*-stop on a given lens.

Underexposure—accidental or deliberate lessening of the light reaching the film. With transparency film, slight underexposure results in more color saturation and higher contrast, an effect preferred by many photographers. Underexposure has the opposite effect on negative film; that is, the negative is lightened and details are washed out, allowing more light to pass through during printing. Resulting prints—whether color or black-and-white—look dark and do not show detail. See also **Overexposure.**

UV filter—one of the most common filters, used both to lessen the effect of ultraviolet rays on color rendition outdoors and to cut through atmospheric haze. Many photographers use it as permanent protection for the lens, since it neither affects exposure metering nor alters hues.

Washed-out color—color that has a bleached or pale (desaturated) look.

X-synchronization—an electrical circuit that permits use of electronic flash. The circuit is designed to fire the flash at the exact instant the shutter opens. See also **M-synchronization.**

Zoom—the technique of changing from one focal length to another to frame or compose a picture properly in the camera's viewfinder; also the short term for "zoom lens." See also the chapter on equipment in *Photography: Buying, Choosing, Using.*

Index